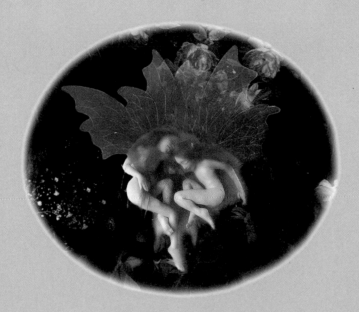

A Midsummer Night's Faery Tale

Wendy Froud & Terri Windling

Photographs by John Lawrence Jones
Photographic Art Direction by Brian Froud

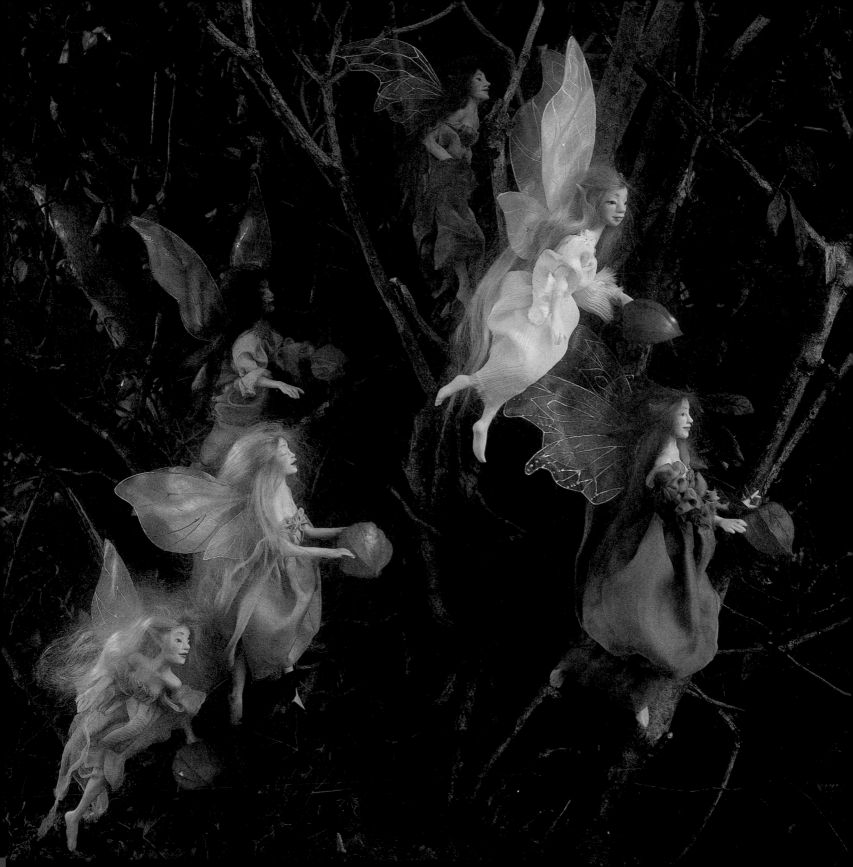

This is a faery story. It doesn't begin "once upon a time" or "in a land far, far away" . . . it begins here in the world we know, in a forest called Old Oak Wood.

Old Oak Wood is a dark and tangled forest tucked into moorland hills, and in that wood dwells one of the faery courts of the British Isles. Now, many folk in our modern world will tell you faeries don't really exist—but this doesn't stop the faeries from going about their daily business, any more than their disbelief in humans would cause us to disappear.

Faeries are contrary creatures, but there is one way they are pleased to oblige us: to humans determined not to believe in them, they remain quite invisible. Yet anyone who has ever suspected that Nature herself has a spirit and soul can learn to see her children, the faeries, flickering through shadows of field and wood. As the Irish poet Yeats once said: "You can not lift your hand without influencing and being influenced by hordes of them"

At dawn of a certain morning in June, the faery court of Old Oak Wood was not particularly concerned with the belief or disbelief of human folk. Those of the court who sleep by night (and, certainly, not all faeries do) woke to the sound of a pipe calling the sun up through the trees. They stretched their limbs, unfurled their wings, and wiped the dream-dust from their eyes. A pale light filtered through the leaves of ancient oak, young rowan, and thorn. The Piper of the Dawn played faery music so high and pure and clear that it could break a human heart, and even the old oaks shivered.

A small faery named Sneezle woke in his feather-lined nest in an oak tree's roots. He wiped the dew from his cheeks and crept out from the leaves and moss. His eyes were bright with anticipation, for this was a faery holiday. Midsummer Night began at dusk—a time of potent magic in the calendar of the faery realm. Mistletoe would be harvested for use in spells throughout the year, and water would be drawn from the sacred spring beneath a hazel tree. Human maids would put flowers beneath their pillows to dream of lovers to come, and farmers would drive their cattle through bonfire smoke for protection from the faeries. At dusk the Faery Queen's Gathering began, and after that . . . well, he wasn't quite sure. Sneezle was just two hundred years old, a mere child in faery years—and in two centuries he'd never managed to stay awake to join the Gathering.

Something wonderful would happen tonight— or perhaps it was something dreadful and strange,

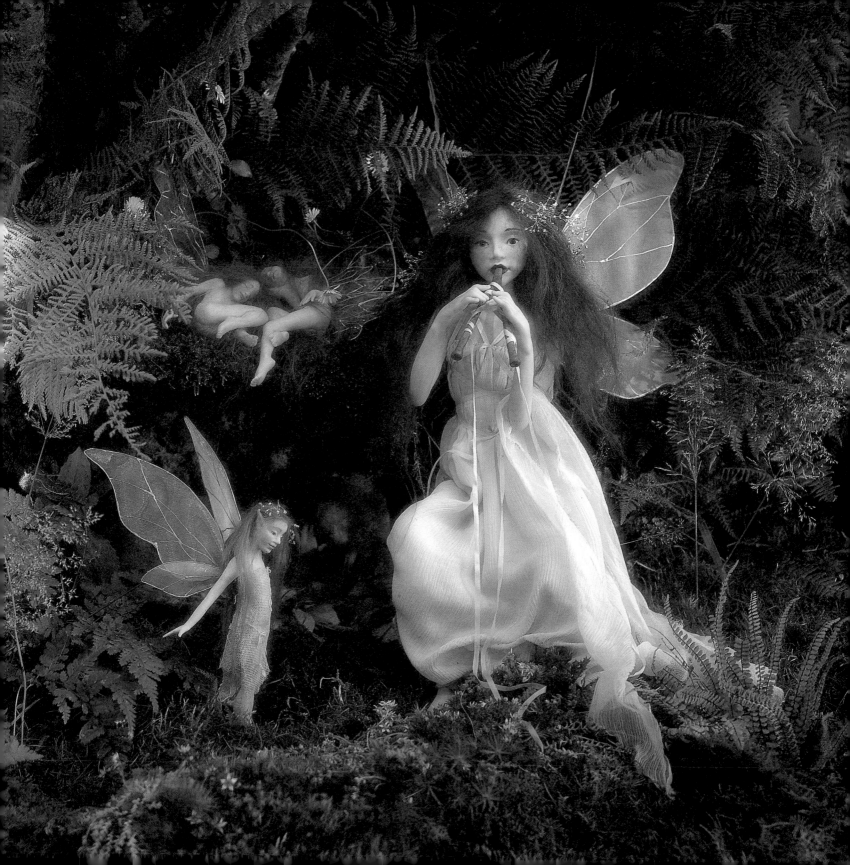

for the faeries have two sides to their natures: the fierce and the gentle, the dark and the bright. Whatever it was that happened on Midsummer Night, this time he would play his part. Sneezle yawned and stretched, picturing himself at the center of bright pageantry—the cupbearer for the Faery Queen, or leading a stately procession through the woods. Surely there was an important role for a handsome young faery like Sneezle. He smoothed his ears and groomed his pelt with his tongue and the back of his hand, like a cat. He brushed his tail and buttoned his coat while the Piper played her morning song, then made his way through the ivy and undergrowth toward the heart of the forest.

Time in the faery realm follows different rules than time in our human world. Although it was summer in Old Oak Wood, spring flowers carpeted the hills and autumn berries hung red and ripe—for plants blooming out of season are always a sign that the faeries are near. Sneezle passed through bracken, under briars, over stones slippery with moss, and found himself in a glade where brittle leaves gusted in a cold wind. A troop of goblins scurried past, carrying bowls of sweet autumn fruit. Wind-sylphs ran at their heels, chilling the summer air where they stepped.

"What ho!" cried Sneezle, his mouth watering, for there's nothing so delicious as goblin fruit. Humans who dare taste it soon waste away, content with nothing less. "Stop! Slow down! I'll help carry that!" He reached for a bowl, and his hand was slapped.

"Hee'cha!" shrieked the goblins in Goblinese, a language of squeaks and giggles and shrieks. Then they disappeared through the bracken, followed by gusts of cold autumn wind. Behind them, warmth returned to the glade; the ferns unfurled and the flowers bloomed, turning their faces to the new morning sun. Two goblin berries lay on the ground, one red as blood and one white as milk. Sneezle put them in his pouch and followed the trail trampled by goblin feet.

As the trail looped crazily through the trees, Sneezle lost sight of the goblins and sylphs, but the brown autumn leaves they left behind gave him a clear path to follow. He breathed in smells of rich, damp earth, tart wild mint, sweet honeysuckle. He heard birdsong, and water chattering, and the distant pipe. Old Oak Wood was quiet and still if you looked at it through human eyes—but Sneezle looked through faery eyes and saw quite a different picture. The shadows were filled with woodland folk—faeries and foxes, brownies and badgers, piskies and porcupines, derricks and deer, all busy now with preparations for the Gathering to come. Tiny green piskies harvested cobwebs, red-eared trolls gathered mandrake roots, and luminous flower faeries wove garlands of ivy and briar roses. Brownies with clothes of bark and moss painted white spots onto red mushrooms. Excited rabbits, always a nuisance, rolled in the leaves and scampered underfoot. Delicate sylphs flew overhead, pouring mist from silver buckets.

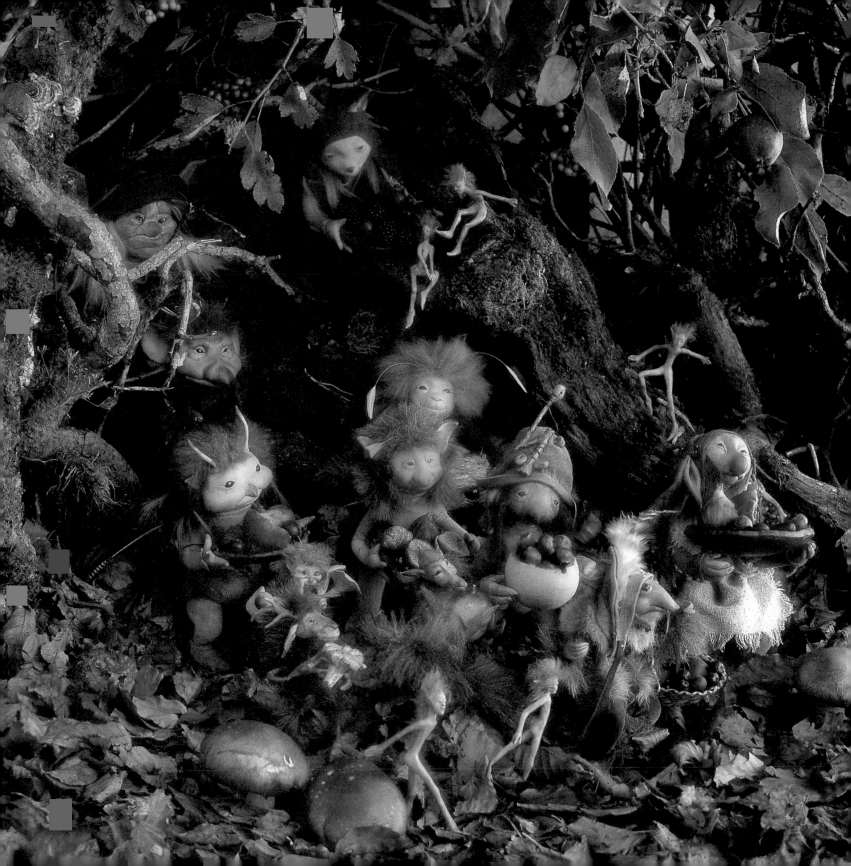

The goblins' trail led to the royal kitchen beneath an oak tree's roots. Toadstool stew simmered on the fire, tables were laden with roots and nuts, and faery godmothers bustled about with knives, spoons, and willow wands. Sneezle climbed down the steep embankment, slipped, slid, rolled head over heels, and crashed into a table piled with berries, sending them flying. Berries spattered a plump godmother hanging freshly laundered wings to dry. She turned with a shriek, then wagged her finger at the red-faced little faery.

"Those frisky rabbits are trouble enough—we don't need children underfoot too! Get up, get up! Get along with you now!"

"I came to help," Sneezle offered meekly, brushing fruit pulp from his clothes. "I can chop or stir or carry or fetch. . . ."

"Your kind of help we can do without!"

"Shoo, shoo, shoo!" said another godmother, prodding at Sneezle's rump with her broom.

The clumsy young faery snatched a loaf of acorn bread and fled up the bank. Putting the loaf in his pouch, he heard goblins giggling in the woods around him.

Sneezle shouldered his traveler's pouch and set off through ivy and oak, following a rabbit path until he reached the banks of a river. Silver-haired faeries with gossamer wings spread wisps of mist in the soft morning light. A faery with quills like a porcupine polished stones by the water's edge.

"Pretty!" said Sneezle, picking up a stone, but the faery growled and bared his teeth. Sneezle dropped it quickly and turned away down the river path.

Clear water ran over smooth black stones and gathered in pools shaded by oaks. River faeries, notoriously shy, hid in the shadows. He crossed the water on an old stone bridge, hearing the sound of music ahead. Soon Sneezle came upon three musicians practicing Midsummer songs. Each one played a different tune in a different tempo and a different key. The sound was terrible, but the three musicians didn't seem to notice.

"Stop! Stop!" the faery cried out, his hands over his sensitive ears.

The musicians looked at Sneezle in surprise.

"Why don't you play together?" he wondered.

The tall piper lifted his chin and looked down his long, boney nose at the child. "That's precisely what we're doing, young man. We're practicing songs for the Queen's Gathering."

"But you're all playing different tunes!" he protested.

The stout percussionist replied, "Of course! We only know one song. Each."

"Then why don't you all learn each other's songs?"

The musicians looked at each other, dismayed. "Never mind him," said the shaggy-haired drummer.

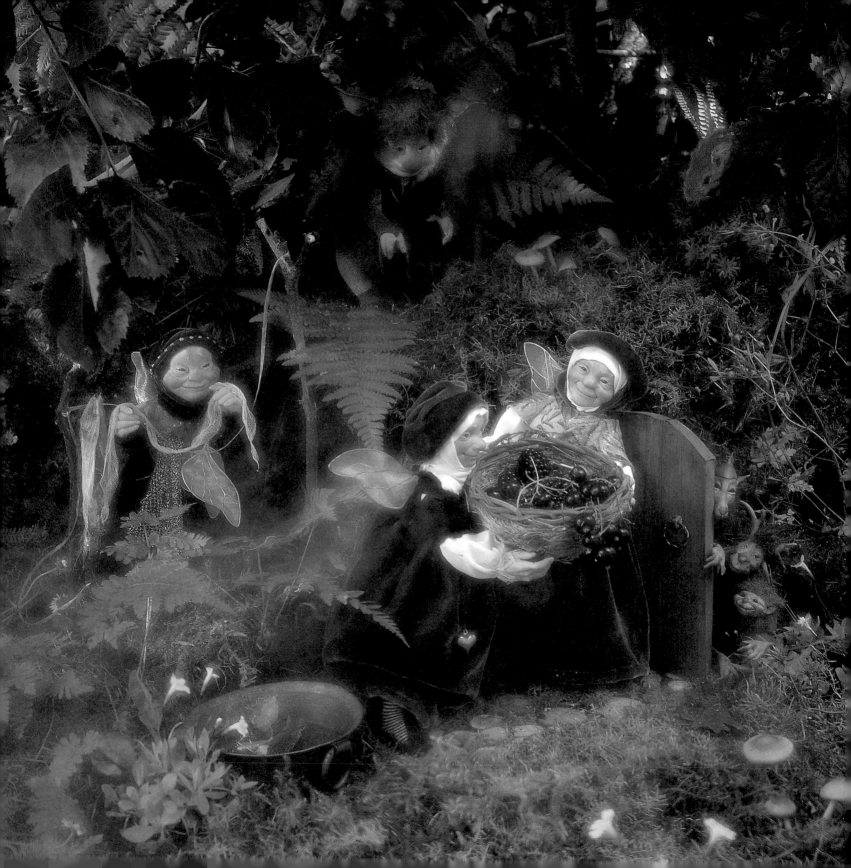

"Not a music lover," the tall one agreed.

"I am so!" Sneezle protested. "*I* know lots and lots of songs." And he folded his hands, raised his face to the sky and began to sing:

> *"You spotted snakes with double tongue,*
> *Thorny hedgehogs be not seen,*
> *Newts and blindworms, do no wrong,*
> *Come not near our Faery Queen. . . ."*

"Stop at once!" cried the first musician.

"That's not a proper tune!" said the second.

"Quite right," said the third. "I've read every text in the Royal Most Excellent Song Archive of the Faery Court of Old Oak Wood, and I assure you there are no blindworms or newts in the whole faery repertoire."

"It's a human song," Sneezle admitted, "by someone called the Beard, the Bard, the Bird. . . . I thought it was rather good."

"A *human* song?" cried the three, outraged.

"Everyone knows," said the stout faery, "that faery music is far superior to the noise of that uncivilized race."

"Come, gentlemen," the tall piper urged, "ignore this young and ignorant creature. We must be ready when evening falls. Take your places and we shall start again, from the beginning."

The faery musicians took up their instruments and made a dreadful sound, while Sneezle fled up the pathway with his hands over his ears.

The sun climbed high above the trees, painting their upper leaves bright gold. The midsummer sky beyond was as blue as the eyes of the Faery Queen. Everyone in Old Oak Wood was busy preparing for the night to come, and Sneezle wandered from glen to grove, anxious to participate. He helped the piskies making garlands of ivy, but all of his garlands were knotted and tangled. He tried to harvest pollen with the foxglove faeries, but it made him sneeze. Then he joined a group of beautiful maidens practicing Midsummer dance steps, but he stepped on so many dainty silken slippers that they sent him away.

Sneezle sat beneath a sturdy beech, combing the burrs and stickles from his tail. As he watched the dancers twirl, a single tear slid from his eye. The musicians were right—he was really just a young, ignorant, useless creature. Midsummer Night could go on without him and no one would even notice.

He sighed heavily and the wind sighed with him, stirring the beech leaves overhead. The branches quivered, and a gravelly voice cried out, "Heads up below!"

Sneezle looked up in surprise as a twinkling star came falling to earth. He jumped up and caught it, the star pulsing in his hand, warm to the touch. "Bravo!" said a tree elf grinning down at him from

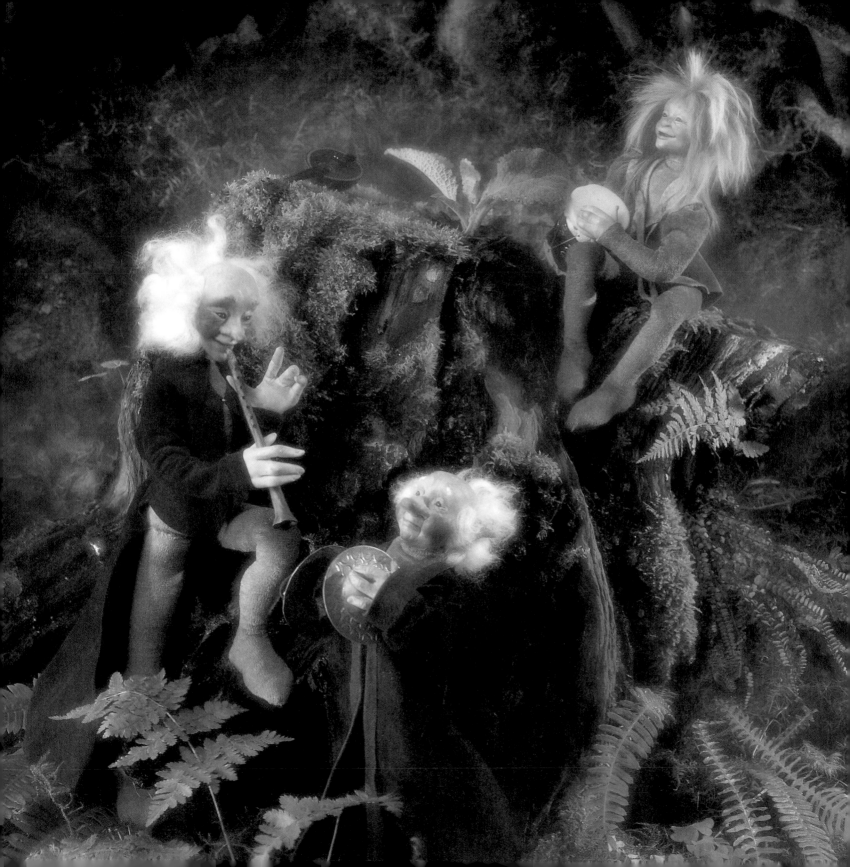

the beech tree's top. A ladder was strapped to the elf's sturdy back, a faery godmother perched on its steps. "Good catch, old boy! Bring us that fallen star and we'll put it back up."

The little faery nodded warily, for the treetop seemed to brush the clouds. Tucking the star into his pouch, Sneezle began to climb. He huffed and he puffed to the highest limbs where the tree elf balanced effortlessly, unconcerned by the whistling wind or the distance to the ground below.

"Not afraid of heights, are you boy?"

"Not a bit." But his voice quavered and the tree elf wasn't fooled.

"You're a tree-root faery—you don't belong up high. It's a good thing you haven't got our job! We're giving the stars a spit and polish so they'll shine their brightest tonight."

"Exactly what *is* going to happen tonight?" Sneezle asked, fairly bursting with curiosity.

"Don't you know?" sniffed the godmother. "What do they teach you youngsters these days?"

"It's Midsummer Night," the elf patiently explained, "the shortest night of the year. Every faery court across the land will celebrate."

"There are other faery courts besides *us*?" Sneezle scratched his furry head.

"Naturally, boy! Every forest and field and hill has its own faery court.

Some are larger than Old Oak Wood, and some are grander than us, to be sure. But we're the oldest of them all, which makes us the best," he bragged. "Each court has its own king and queen, just as we have Titania and Oberon. Yet all the kings and queens bow down to the Lord and Lady of the Wood."

"Who are they?" asked the child, perplexed. "I've never seen *them* in Old Oak Wood."

"No one sees them, boy," the elf explained, "and yet they're always here. They're the ones who turn the seasons around and cause all things to grow. We're all their children—the faeries, the birds, the animals, even human folk. Twice a year we honor them, on the shortest and longest nights."

Sneezle was even more puzzled now. "If no one ever sees this Lord and Lady, how do we know they're real?"

The tree elf laughed. "That's exactly what humans say about us faeries, old boy. And we exist, don't we?"

The ladder swayed with the elf's laughter, while the godmother held on dizzily. "You're distracting my elf," she scolded Sneezle. "Go on, get away with you now—or we'll never reach the stars of the Milky Way before nightfall."

"Go on, boy," the elf said more kindly. "You're not made for heights like these."

The elf was right. The little faery climbed slowly, glumly down to earth. There seemed to be nothing he was fit for. Sneezle sat in the beech tree's roots and watched the graceful dancers in the glade. He'd never felt so shaggy, clumsy, and useless in two hundred years.

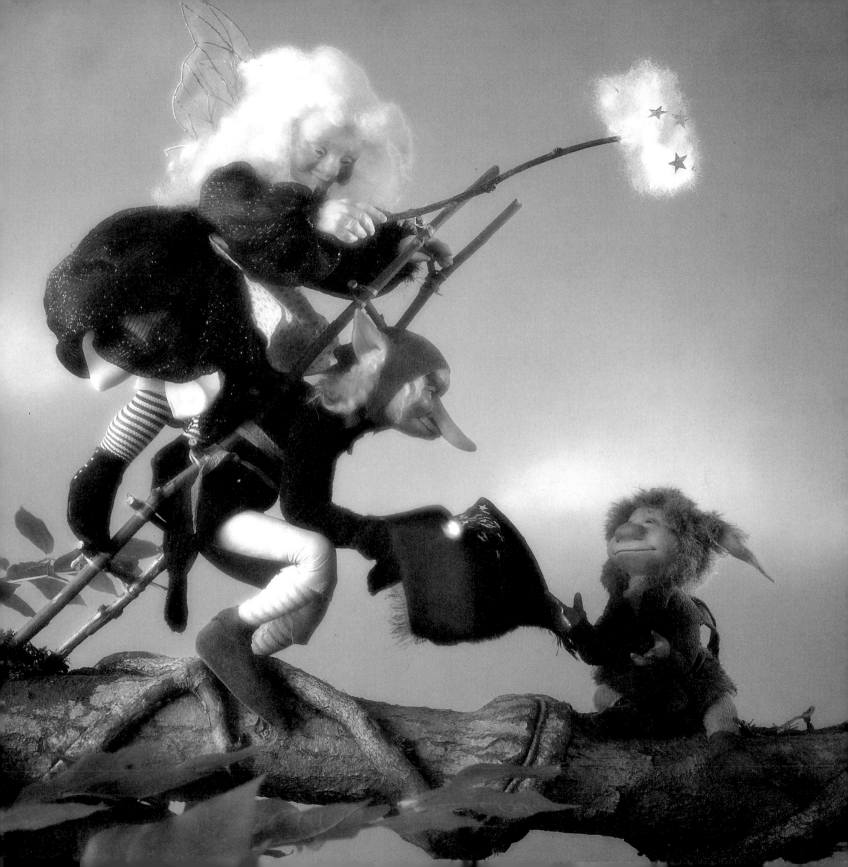

As the midsummer sun climbed to its peak, the dancers tired of their work, bowed to each other, and drifted away. Some strolled into the cool blue shadows of the trees while others took to the air, swooping over the woods like a flock of birds, beating luminous wings.

Sneezle's empty belly rumbled. "It must be nearly lunchtime," he thought. He took the two goblin berries out of his pouch and the acorn loaf.

"Acorn bread? My favorite!" said a musical voice. "Where did you get such a meal?"

Sneezle looked up into the porcelain face of the loveliest dancer of all. Her dress was as white as starlight and her hair as white as soft new snow. "I snatched it from the kitchen!" Sneezle admitted, staring at the ground.

She sat beside him, silken skirts spread carefully over the leaves and moss. "Ill-gotten gains are often sweet," she said, "but I have something sweeter." The faery waved her delicate hand, spoke a word, and a plate appeared filled with pink and white faery cakes. Sneezle's eyes grew round.

"I know you!" the child exclaimed. "I mean, I've seen you at the court. You're one of the royal handmaidens to Her Highness the Faery Queen."

She arched a brow. "Yes, I'm Rianna. And you are an observant young man! I was indeed in service to the Queen of Old Oak Wood."

"Was?" he echoed. "Aren't you anymore?"

She shrugged one shoulder daintily. "All things change on Midsummer Night."

Sneezle watched, licking his lips, as she nibbled on a faery cake. "What changes on Midsummer Night?"

"Why, the new Faery Queen is crowned, of course."

"But Titania has always been our queen!"

The dazzling faery gave him a measured look. "Let me give you a history lesson, little friend. A faery queen only rules from year to year. She's crowned each Midsummer Night. It's true, Titania has reigned for a long, long time—but that could change."

"But, but . . . Oberon *loves* Titania. How could there be another queen?"

Rianna gave a merry laugh. "The fancies of kings are fickle, my dear—they're no different from other men. Come to the Gathering tonight. We'll see who wears the crown this year."

Sneezle put down his acorn loaf, a frown creasing his furry brow. He'd thought the love between Titania and the Faery King was as constant as the moon.

"Oh dear, don't look so worried, child. Here, you can have the rest of my cakes. I'll trade them for your acorn loaf and those two little goblin berries."

Sneezle traded eagerly, for the faery cakes smelled wonderful. His mouth watering, he took a bite . . . and then spat the awful stuff out. It tasted like leaves, mildew, and mud. "This is horrible!" he sputtered. But the beautiful faery was gone, leaving only the sound of her laughter behind.

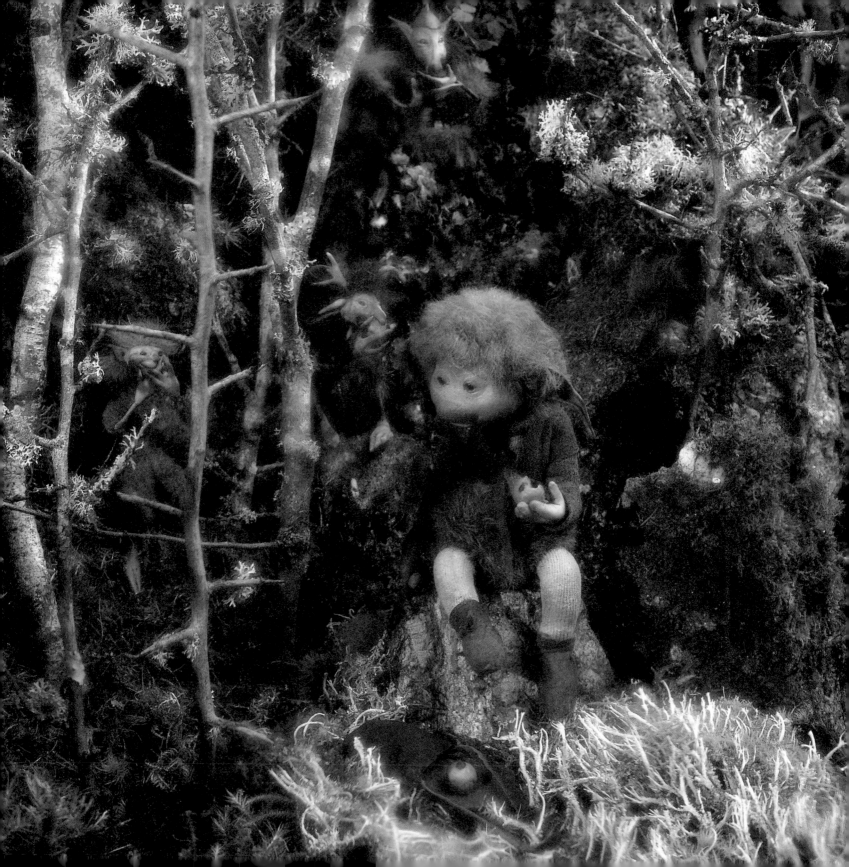

neezle scowled as he picked up his pouch. He was a foolish creature indeed, falling for one of the oldest of faery tricks like a gullible farm boy. As he trudged on through the woods, he puzzled over the things Rianna had said. How could there ever be another queen besides Titania? The love between Titania and Oberon was famed throughout the land. When they quarreled, the trees and flowers drooped; when they made up again, the sun shone brighter. Even human folk told tales about Titania and her Oberon.

The young faery's feet led where they always went when something troubled him. He crossed over the river again, turned left at a standing stone, and followed a narrow pathway to a sylvan glade edged with briar roses. Uncle Starbucket lived beneath the glade in a comfortable troll burrow—and Starbucket was the wisest troll that Sneezle had ever known.

Sneezle crawled through the hedge of briars, then stopped— his mouth open in surprise. For there was the Faery Queen herself, Titania, fast asleep. She lay dappled by summer sun, draped in lace and flower petals, while faery maidens perched among the ferns watching over their queen. A courtier in an oak-leaf coat paced back and forth, wringing his hands. "Oh dear, oh dear, oh dear," he was muttering, "what should I do?"

Sneezle paused, considering. He didn't want to disturb the queen, but she was sleeping right over the tunnel to Uncle Starbucket's burrow. Creeping slowly on all fours, he made his way across the glade, searching for the burrow door hidden by the queen's long hair. A little faery spotted him, but he put a finger to his lips. She smiled, pointing to a hole

beyond the Faery Queen's left elbow. Sneezle scrambled to the hole, dived inside—and then got stuck. Torso wedged in a narrow tunnel, legs kicking in the air above, he tried to wriggle in or out and couldn't move in either direction.

"Help! Help!" Sneezle cried out to the circle of light he spied below.

Uncle Starbucket's face appeared. "Good gracious, is that you, my boy? Why are you coming down that way? My door is over to the right."

"I'm stuck now. I can't get out!" The faery squirmed, twisted, and kicked.

"Oh dear, oh dear, oh dear," muttered the queen's courtier in the glade above. Sneezle felt a foot land on his rump. It gave a mighty push, and then he tumbled down the rabbit hole to the burrow below.

ow kind of you to drop in," said Uncle Starbucket as Sneezle landed at his feet. "How about a nice cup of tea and some cake? You're fond of cake, aren't you?"

"Sometimes," Sneezle said warily, brushing dirt from his soft brown pelt. The gentle troll made a pot of tea and produced a plate of pink and white cakes. The child sniffed, nibbled one, then smiled broadly and gobbled it down, devouring

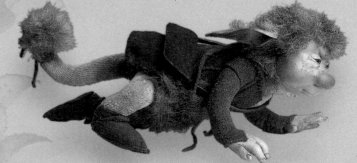

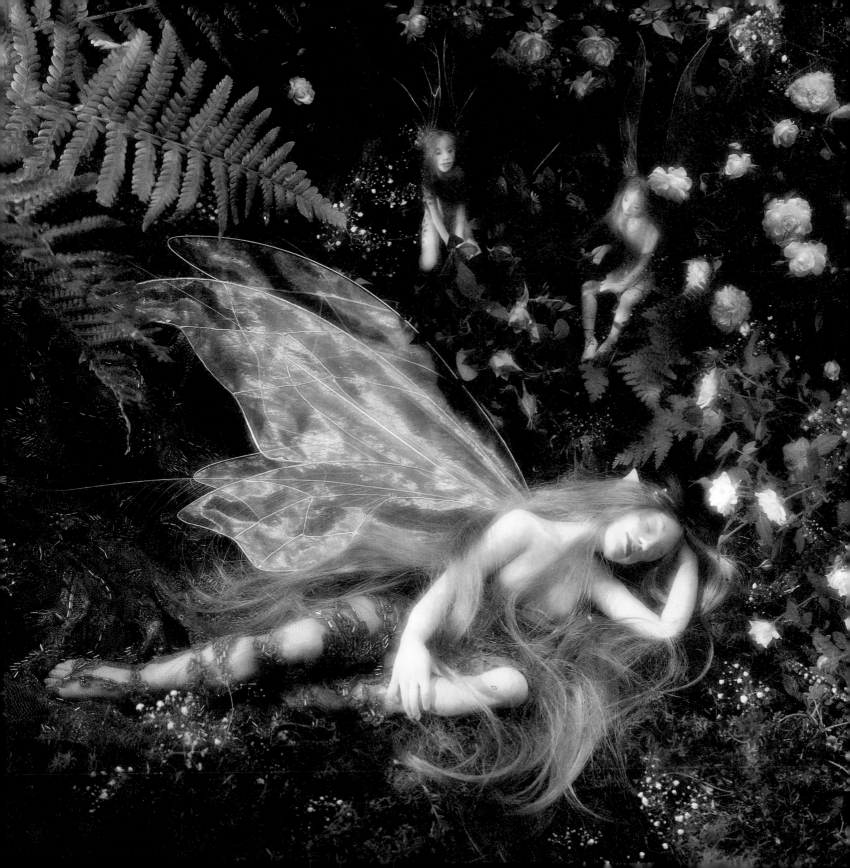

the cakes to the very last crumbs and smacking his lips.

Starbucket filled his pipe with faery herbs, then sat back in his chair. "Tell me, nephew, what brings you all the way to this part of the wood?"

Sneezle, seated at his feet, looked up at the kind old troll gravely. "What happens on Midsummer Night?"

"Wait and see at the Gathering," the troll replied, eyes sparkling. "You'll go this year, won't you?"

"Yes, but . . . Uncle Starbucket, I don't know what I'm supposed to *do*. Everyone keeps shooing me away! I want a job like everyone else—and I don't know what mine is."

The troll puffed on his pipe, considering. "All creatures must follow their natures, boy. You must do what you were born to do best."

"But I'm not good at anything. I'm clumsy and get everything wrong. I mess things up," Sneezle confided, "and everybody laughs at me."

"Well then, Sneezle, maybe that's your role. Maybe you're *supposed* to cause chaos, and stir things up, and make people laugh. Why, that's a fine job to have!" the old troll assured him.

"No it's not," the little faery mumbled, ears drooping around his cheeks.

"Remember: the actions of the smallest faery help or harm all of **Old Oak Wood**. Have patience,

boy. Wisdom is a thing you earn, not a thing you're born with."

Sneezle's ears pricked up at this. "How do I earn wisdom, uncle?"

"There's no recipe for wisdom, boy. Just trust your heart, for the truth of things isn't always clear to the eyes or ears. The world is filled with illusion, child; not everything is as it seems. But the heart is where true wisdom lies—and you have a good one, Sneezle."

Sneezle frowned, scratching his pelt. Adults always talked in riddles like this. He hoped that in another hundred years he would finally understand them.

"Stay awake tonight," urged the old troll as Sneezle took his leave. "And keep your wits about you as you wander through the woods."

"I will," the little faery promised, climbing a ladder of knotted roots. At the top of the tunnel was a heavy door, and he pushed it open.

As soon as Sneezle's head popped above the ground, Titania's courtier grabbed him by the scruff of his neck. "Where are you going?" the tall faery demanded.

"I don't know," Sneezle admitted.

"Then go to the Royal Tailor at once with a message for the king."

"Yes, sir!" Sneezle agreed, thrilled to be of use at last.

The courtier looked at him sternly, and Sneezle sobered under his gaze. The faery's eyes were clouded with worry, and something more that looked like . . . fear. "Tell Oberon that

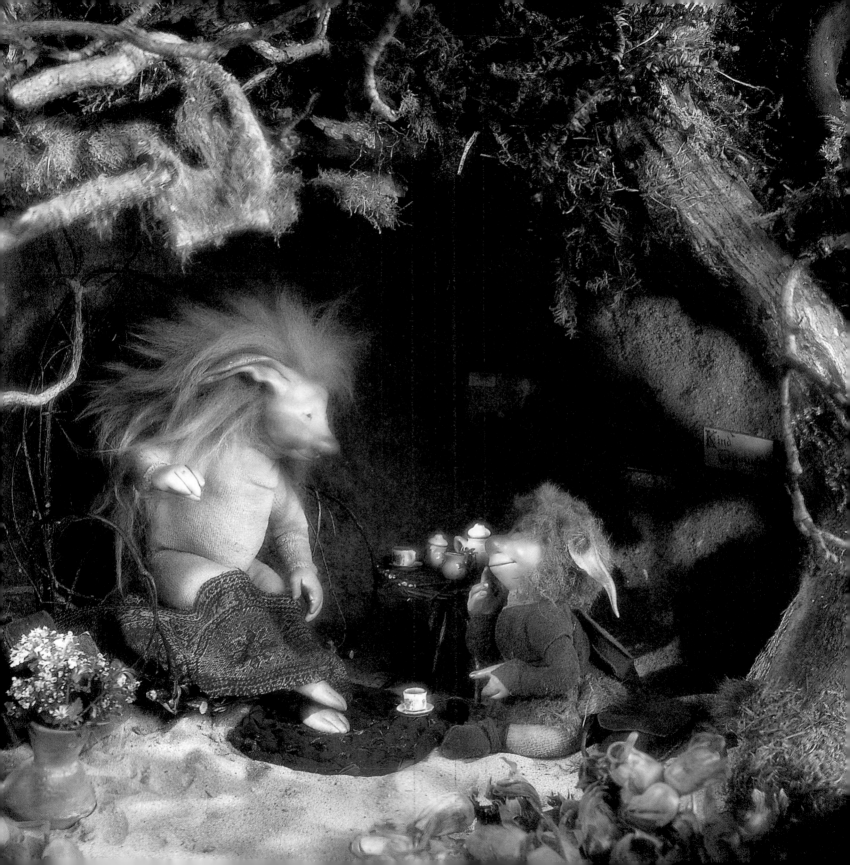

Titania sleeps. Tell him we cannot wake her. She sleeps as though under a spell, and I don't know what to do."

"Right away! Don't worry a bit," Sneezle assured him, "you can count on me." He crawled beneath the briar rose hedge and ran back to the riverside path, making his way as fast as he could to the grove where the tailors worked.

The tailors' workshop was in chaos. Bolts of silk, satin, velvet, and lace were strewn about the grove, and a dozen faery seamstresses were busy with needle and thread. Oberon, the King of Faery, stood draped in velvet and silver leaves while the Royal Tailor fluttered about, cutting, tucking, and stitching. The king wasn't pleased. His eyes, which often changed color, were stormy gray right now. Sneezle was out of breath as he approached. "Y-your majesty?"

Oberon looked down at the shaggy faery kneeling at his feet.

"Your kingship, I have a message for you. The Queen of Faery lies asleep. She can't be woken. She—"

Oberon swore an oath that made the little faery blush. "What nonsense is this? I've waited and waited for her, and you say she lies asleep? On this day of all days? She should be here! I suppose she's dallying with changelings again. I am *most* displeased." His eyes darkened ominously. "And where are her attendants?"

"I'm here, my lord." Rianna emerged from the shadows and curtsied gracefully.

"And so you are," Oberon replied brusquely. "But where are the other three handmaidens? And where is my queen?"

"It is as the child says, my lord. She's dozing in the summer sun."

"They can't wake her up," Sneezle persisted.

"I tried to wake her," Rianna interrupted, "but she refuses to be disturbed."

Oberon's eyes turned black as thunderclouds with his annoyance.

"I'm terribly sorry, Your Highness," said the lovely handmaiden. "Can *I* be of help?"

Oberon gestured, and she came close, crossing the grass with graceful steps. Her snow-white hair was vivid beside the king's, as black as crows.

"Your kingship," Sneezle tried again, but Oberon's eyes were on Rianna. Her beauty seemed to dazzle him, distracting him from his anger.

"Might I make a suggestion?" she asked. "Let me try on Titania's dress. I'm the same size as the queen, my lord, so why don't I stand in for her?"

"A good suggestion," Oberon agreed. He turned abruptly and clapped his hands. "Tailor, give this woman the Midsummer dress, and be quick about it."

Rianna curtsied once again and stepped behind a curtain of leaves, followed by two seamstresses and a crowd of court attendants. Oberon paced impatiently until Rianna reappeared—and then he stared, as did Sneezle. The Midsummer gown was beautiful,

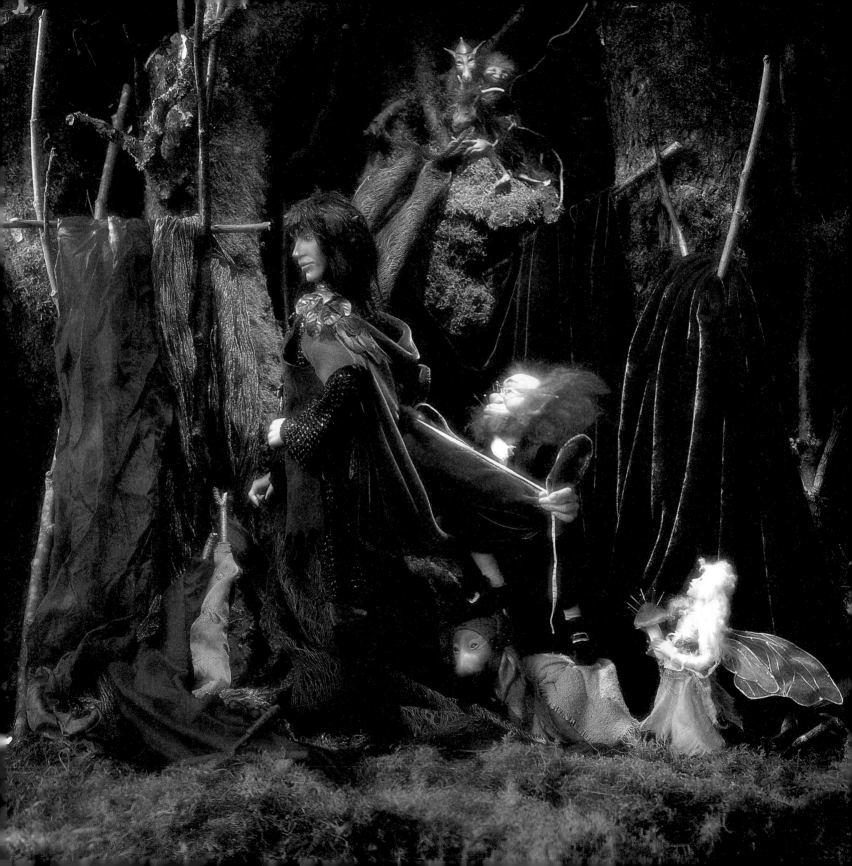

made of the finest cobweb lace stitched with stars, flower petals, and pearls. It fit the faery perfectly and made her lovelier still.

The tailor beamed. "Exquisite!"

The Faery King collected himself. "Yes, it will do," he said gruffly. "Titania will be pleased, no doubt. Make sure that all is ready before dusk falls, including her crown."

"The crown is still with the oaks, my lord."

"What? Why isn't it here?" he demanded.

"Her Majesty usually sends one of her handmaidens to get it, sir." The nervous tailor wrung his hands. "But if she lies asleep, then I don't know—"

"Don't worry, my lord, I'll fetch it," Rianna spoke up eagerly.

The tailor smiled gratefully, but the king's eyes suddenly narrowed. He gave the faery a speculative look and asked, "Where are the other handmaidens? There should be four of you."

Rianna shrugged. "They've disappeared. Perhaps they're all asleep as well. But I know the way to the Heart of the Wood. Send me for the Faery Queen's crown."

"No . . . no, I think not," said Oberon. "You must attend your queen." He looked around the tailors' grove and his eyes fell on a small seamstress. "You, girl. You can go."

"Me?" The little faery stared.

"Yes, you. Come forward. What's your name?"

"T-T-Twig," she stuttered as she smoothed a ragged skirt and curtsied to the king.

"*She's* not a handmaiden," Rianna protested.

"But I hope to be someday," said Twig. Her voice was shy and her head was bowed before the gaze of the king.

Oberon ignored Rianna and addressed the little seamstress gently. "You must go at once to the oldest oak, who sleeps and dreams at the Heart of the Wood. There you will find the Midsummer crown. Bring it back here for the queen. And you"—he turned to Rianna—"go and tell my queen it's time to wake. And find the other three handmaidens, for you will *all* be needed tonight."

Sneezle tugged at Oberon's sleeve until he had the king's attention. "Your Highness, Queen Titania *can't* wake up. She sleeps as if she's under a spell. . . ."

"A spell?" King Oberon repeated, his anger gone immediately, replaced by worry and alarm. "Where does she sleep?" he asked the little faery. "Tell me quickly!"

"Among the briar roses, sir. In the glade where old Starbucket lives."

The Faery King summoned his mount with a single word from the Old Language. He leaped to the back of the black unicorn, kicked its flanks, and left the grove, galloping through the tall trees while his startled retinue took to the sky.

Rianna frowned, took off Titania's dress, and then she, too, left the grove. Her eyes rested on Sneezle as she passed, her

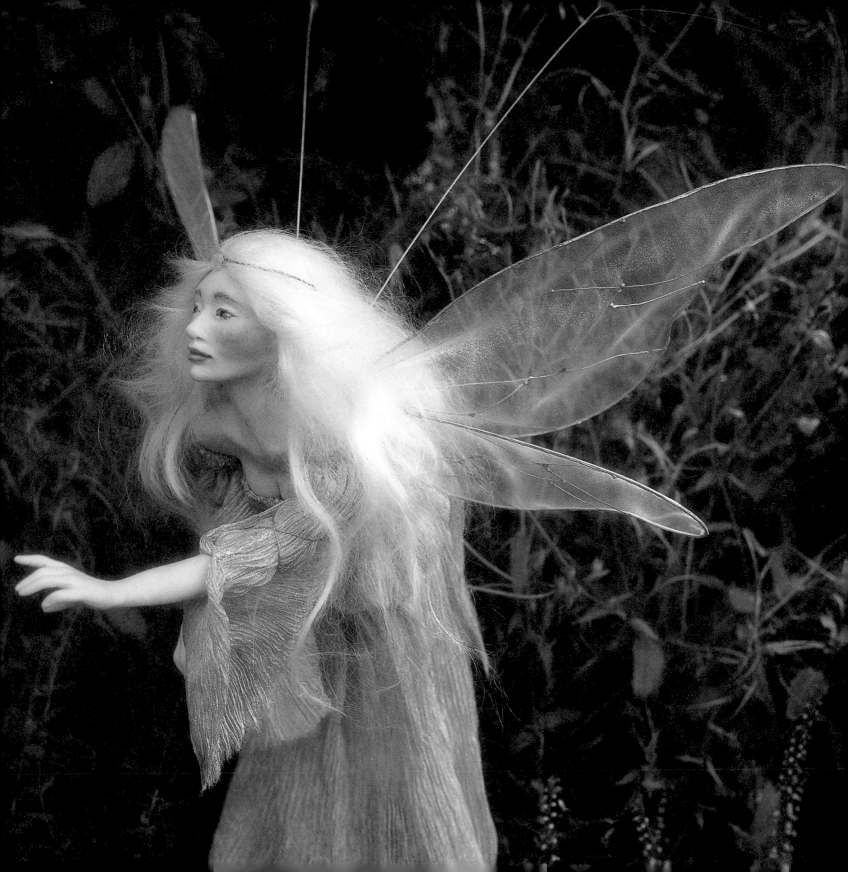

expression grave.

The faery seamstresses bent back over their work, all chattering noisily now.

"The king . . ."

". . . so tall!"

". . . so handsome!"

". . . so elegant!"

". . . but imagine, choosing Twig!"

Everyone in the tailors' grove turned and stared at the young seamstress.

"*I* should be the one to go for the crown," the Senior Seamstress complained. "After all, I'm the eldest here."

"No, I!" said the Hat-and-Wig Maker. "For my job takes more skill."

"Don't be silly," said one of a pair of maidens modeling Midsummer clothes. "We should be the ones to go. We're far more beautiful than Twig. She shouldn't even appear before the court, let alone the oldest oak! Look at her! Her dress is torn, her hair is tangled, her feet are covered with soot! And look at those wings, all crumpled up!"

"Enough!" The Royal Tailor clapped his hands. "Twig was chosen, so Twig must go. Away with you, girl—stop dawdling. The king gave you an important task. And away with you, young man," he said to Sneezle, "we have work to do!"

"Let him stay," said the Hat-and-Wig Maker. "Without Twig we're one hand short."

The Senior Seamstress snorted in derision. "What use do you think he'd be with those paws?"

"He's as shabby as Twig," said one of the pretty maidens.

"Worse!" the other giggled.

Red-faced, Sneezle left the tailors' grove, their laughter trailing behind him.

Beyond the grove, Twig stood dejectedly among the flowers and ferns. She turned as Sneezle approached and he saw tears bright on her cheeks.

"What's the matter?" Sneezle asked her.

The youngest seamstress wiped her eyes with a ragged handkerchief.

"Never mind those horrid faeries," said Sneezle. "They're all just jealous of you. The king gave you a wonderful, important job. You should be pleased."

"I am, I guess," Twig answered doubtfully. "But those awful faeries are right—just look at my tattered, crumpled wings! I've been working so hard, I haven't had time to get them mended, washed, and ironed. I thought I'd go to the laundry this afternoon, and now there won't be time. How can I appear before the oldest oak, or the queen, like *this*?"

"They're not so bad," Sneezle assured her. "Turn around and I'll straighten them out." But when Sneezle pushed and pulled her wings, he only twisted them more. The little seamstress looked back at them, and then she burst into tears again.

"Please don't cry!" said Sneezle anxiously. "Look, Twig, I know what to do. I'll go and fetch the crown for you—while

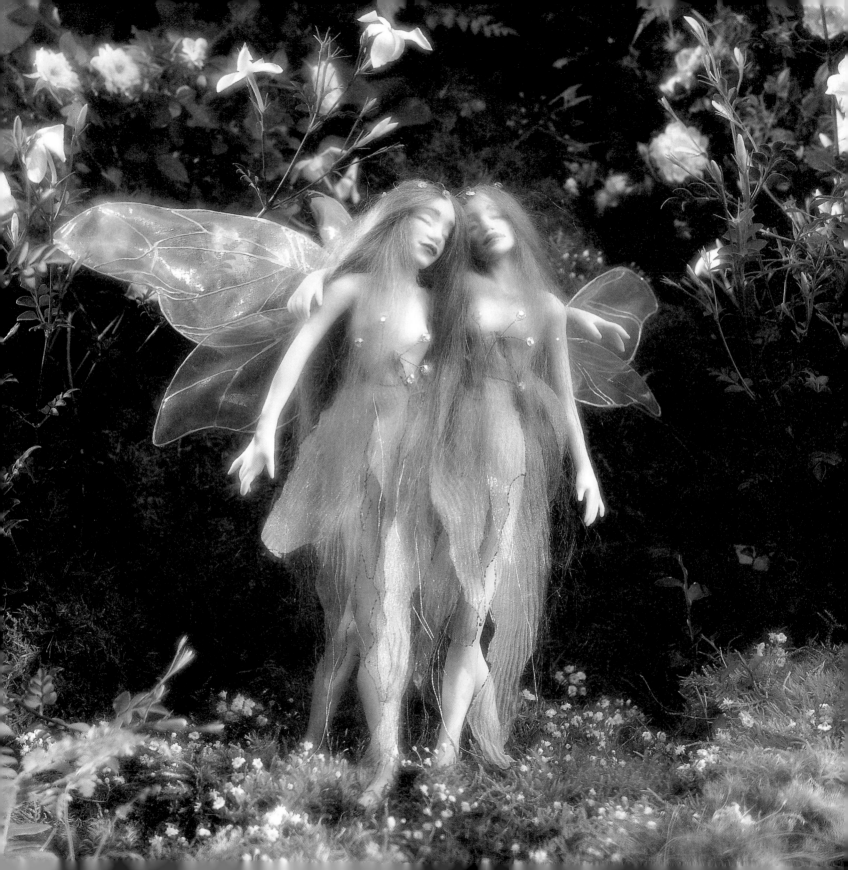

you go to the godmothers and get your wings fixed up."

She sniffed. "But what if the king finds out?"

"He won't. It will be our secret, okay? I'll go right to the Heart of the Wood—"

"I have no idea where that *is*."

"I'll find it. I'll bring the crown to you, and you can give it to the king."

Twig lifted her dirt-smudged face, eyes bright beneath dandelion-puff hair. "Then I could get cleaned up for the Gathering. But are you sure? It's such a very important job . . ."

"Indeed!"

Twig gave him a shy, sweet smile. "I don't even know your name."

"Sneezlewort Rootmuster Rowanberry Boggs the Seventh," he told the seamstress grandly. "But all my friends just call me Sneezle."

"Sneezle, thank you very much. You're being awfully kind to me. I'll meet you right back here before dusk falls, okay?"

"Okay!"

Although he'd said he'd find the way to the oldest oak at the Heart of the Wood, in fact Sneezle had never been to that dark part of the forest. He struck off on a path to the west where oak and ash grew close together, following his nose and hoping it led in the right direction. He was thrilled to have a job at last—more than a job, an actual quest! And yet, as he left familiar ground and the woods grew thicker and darker around him, his spirits began to sink, his smile faded, and his steps grew slower.

Here, the air was damp and cool. Lichen covered the thick oak roots and mushrooms sprouted among the rocks. Cobwebs stretched across a path that was narrow and overgrown. Mice rustled in the undergrowth, but the birds were silent overhead. Sneezle took a breath and continued on. He couldn't let Twig down.

The trail led through a tangle of briars that snatched his clothes and scratched his hands. Batting them aside, the little faery forced his way up the forest path. He spied a glint of color ahead—a rusty sword, half buried in earth, held tightly in the grip of thorns. Beyond was a knight's chain mail, a broken lance, a shield turned green with moss—then something that looked like bones in a bed of roses. He hurried on.

The path grew even narrower, disappearing into bracken and briars, and our hero came to a sudden stop. He didn't know which way to go.

Something skittering on the ground made Sneezle jump. It was only a mouse, trotting busily up the path . . . but then it turned and looked at him. "Are you lost, young man?" the mouse piped up.

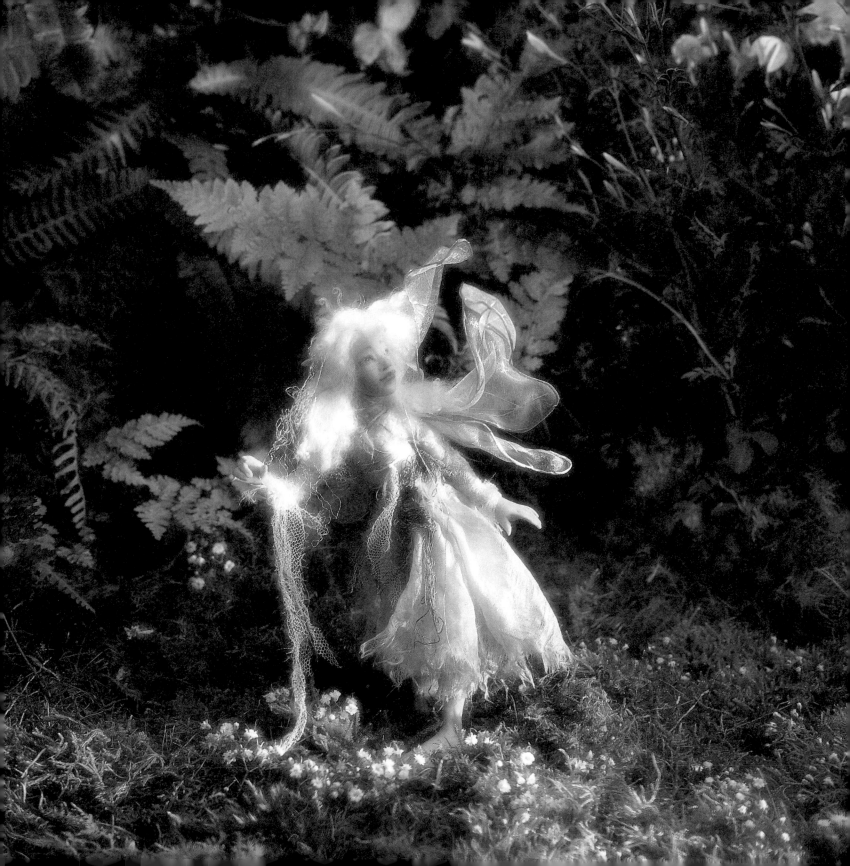

"I am," the little faery admitted. "I'm trying to find the Heart of the Wood."

"You're on the right path," the mouse assured him.

"But I can't see it under the thorns!"

"Then follow me, for I can see it clearly from down here. But first, you must retrieve the sword that lies buried in thorns and earth."

Sneezle scratched his head. "If you say so. But it's just a bent, rusty old thing."

"Never judge by appearances," cautioned the mouse as she followed him. She sat daintily on her two hind legs while Sneezle pushed through roses and briars, grabbing the old sword by its hilt and giving a mighty tug. The thorns released it suddenly, flipping the little faery backward. He tumbled out of the briars, scratched and bruised, clutching the sword.

He laid the sword before the mouse. She looked it over carefully while Sneezle pulled thorns from his pelt, and then she touched the hilt with one gray paw. The rust disappeared. The sword straightened before his eyes, glowing with a soft and silvery light.

"Its name is Truesight," said the mouse. "It was made by Wayland, the faery smith. You must carry it with you. How can a hero go on a quest without a sword?"

"I'm not really a hero," Sneezle admitted.

"That still remains to be seen," she replied.

"Now come with me."

He picked up the sword and followed the mouse. She led him through bracken and briars until at last the undergrowth thinned and the trail was clearly marked again, running through tall trees twisted with age and draped with ivy. "Keep to the path," the mouse advised, "and soon you'll reach the Heart of the Wood."

"Thank you, Mouse," said Sneezle. "Is there anything I can do for you?"

"Why, yes there is, since you're courteous enough to ask," the mouse replied with delight. She lowered her eyes and folded her paws. "Please, child, cut off my head."

"What?" cried Sneezle. "I'd never do that!"

"But you must!" insisted the little gray mouse, her voice more urgent now. "Don't be afraid. I promise that only good will come of it."

"But I don't want to harm you, Mouse!"

"I won't be harmed. Please, do as I ask. You have Truesight. You have courage."

Sneezle gulped. He didn't have courage at all. But he picked up the sword, his hands trembling. It seemed to be made of light, not steel. He swung Truesight, and the light passed through the mouse's neck. She began to glow. The air shimmered and then the mouse became a slender maiden with wide gray eyes, dainty little hands and feet, and a dress made of leaves.

The faery maiden blinked, then smiled.

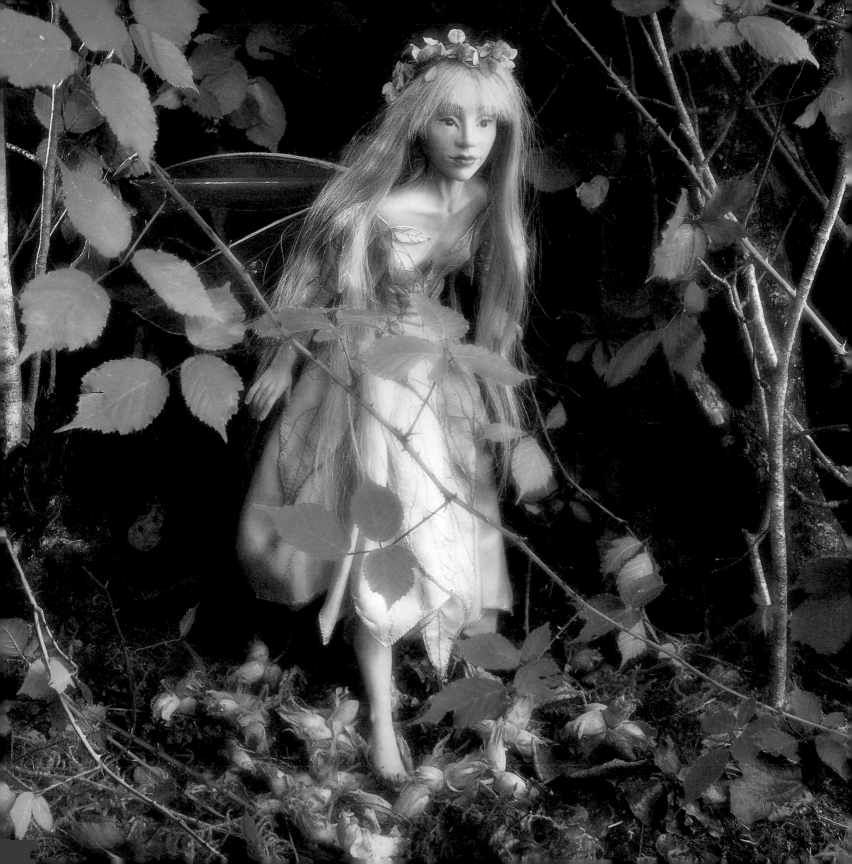

"My very own shape again, at last!"

"W-what happened?" said Sneezle. "Are you the mouse?"

"I was," the mouse maiden explained, "for a wicked sorceress put me under a spell. You broke the spell with Truesight, and I am very grateful indeed. Now let me give *you* a gift that just might help you on your quest."

She handed him a hazelnut, then lifted herself on glittering wings and disappeared into the eastern sky over the trees. Sneezle looked at the nut, perplexed, put it carefully into his pouch, then shouldered Truesight and continued on the path leading to the west.

The child walked until the path suddenly divided into three directions. Each trail ran deep into the shadowed trees. Which should he take?

"Are you lost, young man?" said a voice from above. A raven sat on a high oak branch.

"I am," said Sneezle. "Can you tell me which way goes to the Heart of the Wood?"

"Certainly," the bird agreed. "From here, I can see in all directions. Don't take the broad and sunlit road—it leads into a goblin bog. Don't take the straight and narrow road—it leads to the human world. You must take the road that lies between, following moss and mistletoe. That is

the path to the Heart of the Wood, my friend."

"Thank you!" said Sneezle. The little faery turned to go, then remembered his manners and addressed the bird. "Er, is there something I can do for you in return, Raven?"

"Yes, there is, since you're good enough to ask," the raven answered gratefully. She turned one bold black eye to Sneezle. "Please cut off my head."

"I was afraid you were going to say that. But I'll do it if you insist."

The raven swooped down from the oak and stood waiting at Sneezle's feet. He took a breath, clutched Truesight in two hands, and swung at the bird. The sword blazed with a brilliant light, the air shimmered, sparked, and smoked, and then the bird became a bold maiden with raven-black hair.

The raven faery brushed feathers off her skirt and laughed with a husky voice. "My very own shape again, at last! I owe you a debt indeed, young man. A wicked sorceress put me under a spell, but you have broken it. Here, let me give you something." And she handed him a red rowanberry.

"Thank you," Sneezle said politely, putting the small berry in his pouch. The faery took to her wings and soon vanished on the eastern horizon.

Sneezle draped his pouch over one shoulder and balanced Truesight on the other, then followed the winding path through low green hills crowned with ancient trees. He followed the path uphill and down until he reached a riverbank. Then he sat down on a rock, dismayed, for there was

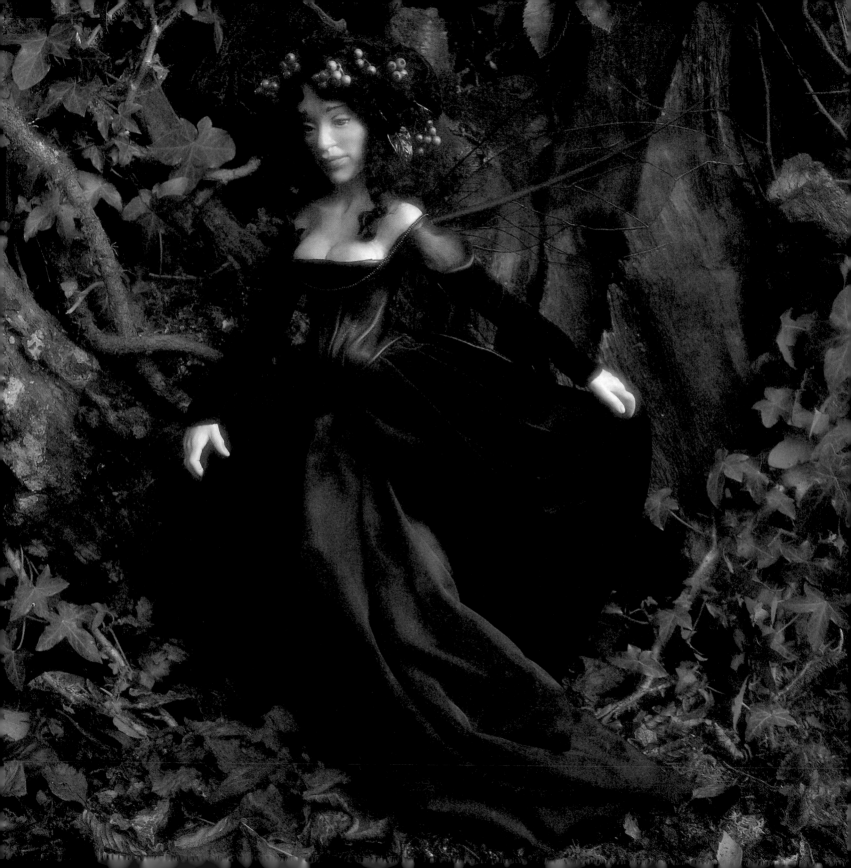

no way to cross the water. There was no bridge, no stepping-stone, and the river looked deep and treacherous. As the little fellow sat frowning, a gentle voice behind him asked, "Are you lost, young man?"

Turning, he saw a small white deer with eyes as green as summer grass. She spoke with a woman's voice, yet she was crowned with delicate horns.

"I need to find the Heart of the Wood," Sneezle explained to the beautiful creature. "But I don't know how to reach the path on the other side of the river."

"Climb on my back," the white deer said. "I'll carry you to the other side."

The deer knelt down beside the faery and he scrambled up on her smooth white back. When she entered the river and began to swim, the water felt strangely warm.

"What is this river called?" he asked as the white deer reached the opposite bank.

"It hasn't got a name," she told him. "It comes from the world beyond the wood. All the tears the human folk shed flow here through the faery realm."

Sneezle dropped down to the stones. "Thank you, Deer, I'm much obliged. I suppose now you want me to cut off your head . . . ?"

"Yes, child, if you'd be so kind," the white deer answered softly.

The young faery gripped Truesight and swung the sword with all his might. Lightning flashed. The air sparkled, and then the white deer disappeared, turning into a

woman with long white tresses and a crown of horns.

"I remember you!" Sneezle exclaimed. "In fact, I remember all of you now! You're Titania's handmaidens. Rianna told us you'd disappeared."

The gentle faery's eyes grew dark. "Rianna is the one who cast these spells, trapping us in animal shape."

"*She's* the wicked sorceress?"

"More wicked than we ever knew! She seems to want us all out of the way on Midsummer Night."

"Did she put the queen to sleep as well?"

The maiden stared at him, aghast. "Is Titania under a sleeping spell? That sounds like Rianna's work indeed! I must return to the queen right away—and I think you'd better come with me. It's dangerous for a young creature like you in this part of the wood."

Sneezle shivered, suddenly chilled. There were things going on that frightened him and riddles he did not understand. But Twig was counting on him to fetch the crown from the oldest oak.

"I'm on a quest," he said solemnly. "I won't turn back until it's done."

"Ah, a quest. I won't interfere, though it troubles me to leave you here. At least let me give you a gift, little hero. Let me give you what protection I can."

She took young Sneezle by the hand and led him up the riverbank. There, half buried in ivy and moss, stood a stone with a round hole at its top. Water was bubbling through the hole and cascading in a natural fountain. The maiden cupped two

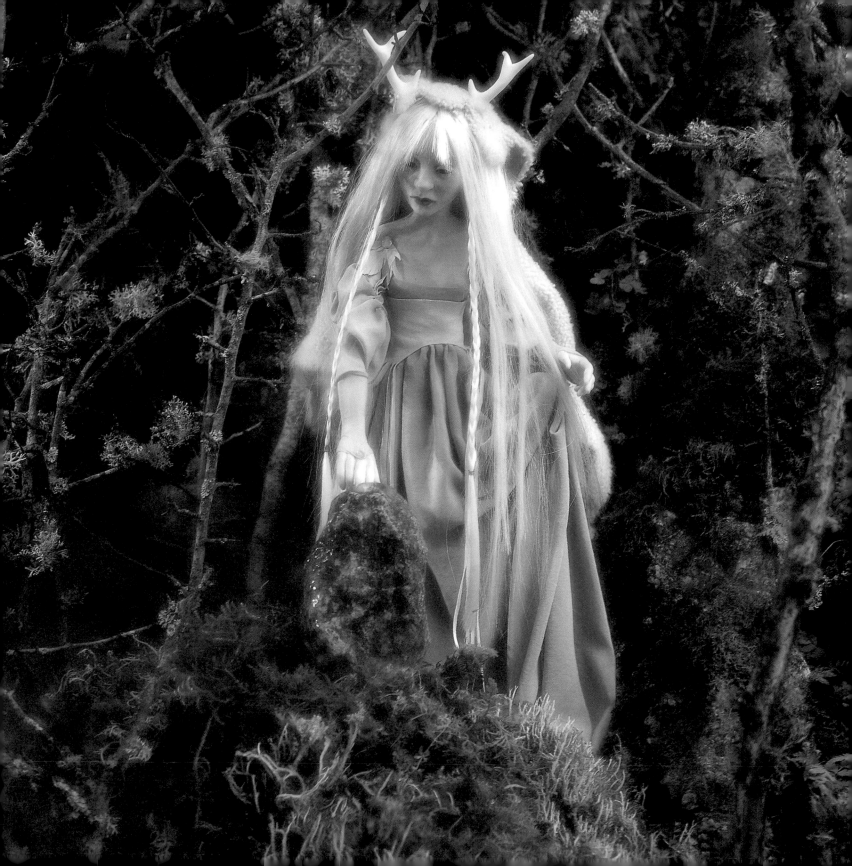

slim white hands and gave Sneezle water to drink that tasted deliciously of wildflowers and sweet honey.

"I say, I'd like some more of that!"

The maiden smiled, but shook her head. "That's plenty for a little fellow. The magic in this water will protect you from enchantment, child. Now take this." She handed him a small white pebble, round and smooth. "Keep this safe until you need it most."

"Need it for what?" Sneezle stared at the simple stone, his face wrinkled with puzzlement. But when he turned back to the handmaiden, she'd already disappeared.

Placing the pebble in his pouch with the hazelnut and the rowanberry, Sneezle picked up his sword once more and followed the winding path. Here the trees grew thick and close, their gnarled roots knotted together. Above, the leaves blocked out the summer sun and the wood was dark. A chilly mist rose from the ground, thickening with every step. Truesight glowed softly, lighting the way through the eerie gloom.

Ahead, the ancient Heart of the Wood lay in a grove of holly and oak. Points of light flickered in the trees like stars or will-o'-the-wisps. As he drew close, Sneezle saw the light was made by candles dripping wax onto a massive chair of ivy roots, oak boughs, and horn. An old wizard was sleeping

there, draped in mildewed velvet robes. Sneezle approached, looking for the oldest oak, and the wizard woke up.

"Stop right there!" The wizard pointed his long finger at Sneezle's nose.

"W-w-who are you?" The young faery trembled under the wizard's fierce gaze.

"Who am I?" The wizard scowled blackly. "Who am I, you dare to ask? I'm the guardian of the Sacred Grove at the Heart of Old Oak Wood. Who are you?"

"S-S-Sneezlewort, from Greenmoss Glen. I've come to see the oldest oak."

"You have, have you? Impossible. So turn around and go back home."

"Go? Oh no, I can't just go! Not until I fetch the Faery Queen's crown. I'm a messenger from King Oberon," the little faery explained. The guardian looked him up and down. "I've already foiled one false messenger today, and she was a clever, pretty kind of thing. What makes you think I'd give the crown to a foolish creature like you?"

A false messenger? Had Rianna come despite the wishes of the king? Now he *had* to convince this crabby old wizard to let him past! Frantically, Sneezle tried again. "What must I do to get that crown?"

"Eat seven loaves of iron bread. Wear out seven pairs of iron shoes. Climb seven iron mountains. Then come back, and I'll reconsider."

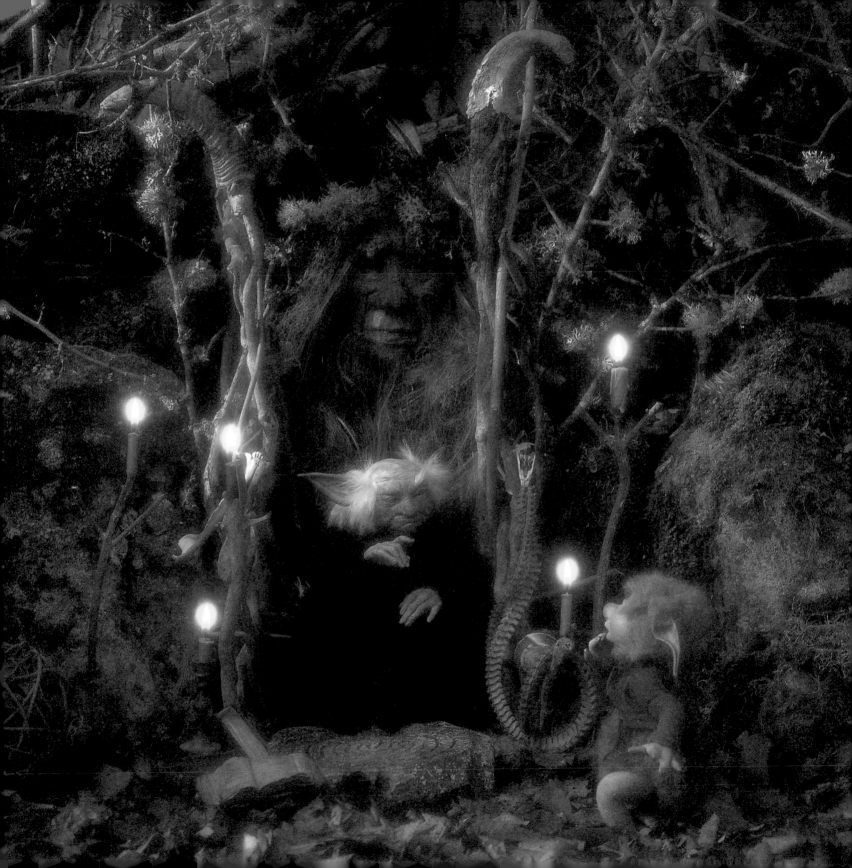

"But Titania needs the crown tonight!"

"That's not my problem," the guardian snapped.

Sneezle scratched his furry chin. What would a proper hero do? "I could trade you something for the crown. What do you want? My buttons? My boots?"

"No and no!"

"My sword?" he offered.

"That old thing?" the guardian scoffed, but his eyes betrayed a sly interest. Sneezle hated to lose Truesight, but he swore he'd get that crown for Twig. Placing the sword at the wizard's feet, he bid it a silent goodbye.

Scowling still, the wizard nudged the silver hilt with a velvet toe. "Come back later. I'll keep the sword and think about your offer."

"I need the crown right now!" protested Sneezle.

"Quiet!" roared the guardian.

The young faery took two steps back, his hand over his open mouth—for behind the wizard, a huge face had appeared within the shadows of the trees. Its skin was brown and rough as bark, softened by moss, wrinkled with age. Yawning with a rumbling sound that echoed in the earth below, the oldest oak opened its eyes, and Sneezle sank to his knees.

"This little one will carry the crown," said a voice like wind through autumn leaves. "He shall carry it with the blessing of the trees. So says the wind. So say the oaks." The wind rose, and oak leaves made a murmur like voices overhead.

Sneezle raised his head to speak, but before he'd even opened his mouth the eyes had closed and the face had faded back into the darkness.

The guardian hunched down on his throne. "All right then, have it," he muttered grudgingly. "You'll find it in the hollow of the tree."

Sneezle passed the throne and approached the old oak tree behind with awe. "Th-thank you, s-sir," he stuttered, but the oldest oak was asleep once more, snoring softly, dreaming of wind, water, and rich brown soil. Reaching into a hollow in the trunk, the little faery felt leaves and moss and something that was sharp and cold. He grabbed, pulled, and then beheld a silver crown crusted with gems. "The Faery Queen's crown!"

"So it would appear," the wizard answered testily. "If you're satisfied, then be on your way."

Sneezle was happy to oblige, eager to take the crown to Twig. He headed down the path, while the guardian shouted, "And don't come back!"

neezle scampered down the trail, leaping over roots and rocks—and then stopped cold at the riverbank. The river of tears was gone. The gully was dry where it had been, covered with grass and mushroom rings. He took a single cautious

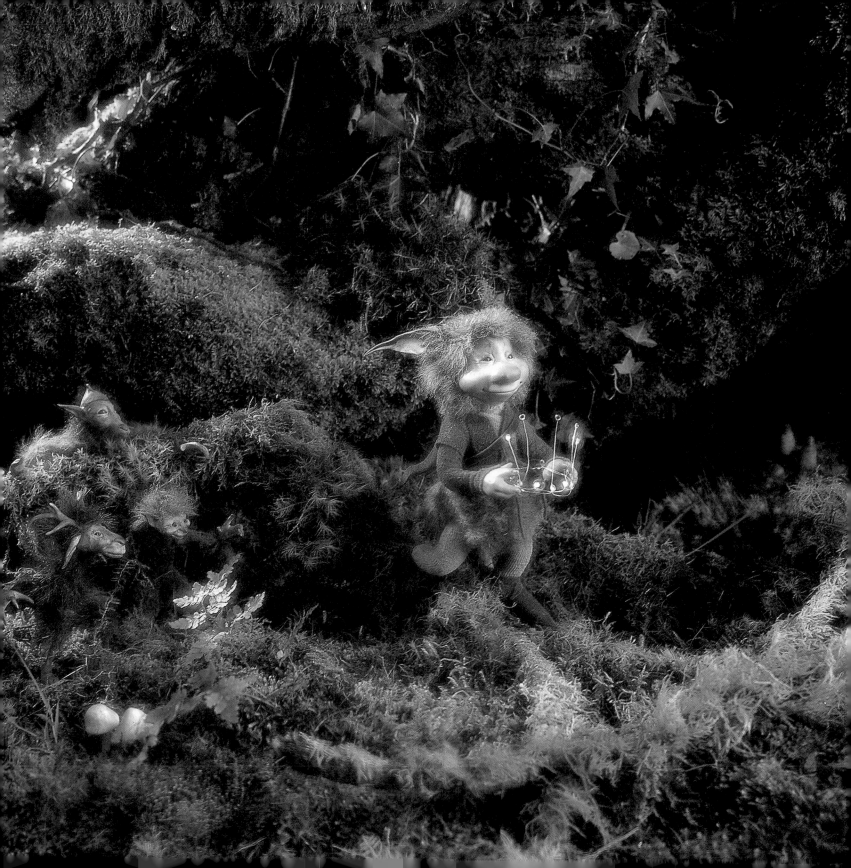

step, for mushrooms meant magic was afoot. What kind of spell could make an entire river disappear?

"The river moves from place to place. It never stays still," said a musical voice. Whirling, Sneezle found Rianna standing on the path behind him.

She smiled. Her face was beautiful as ever, but hard and cold as ice. "What a surprising fellow you are! And such a resourceful child, too. I couldn't persuade that decrepit old oak to give the Faery Queen's crown to me, yet *you* bear it off like a prize from a country fair. Twig will be ever so pleased! Now give the crown to me, little boy, and I'll get it to her safely."

"How did you know our secret?" he demanded.

"I overheard the two of you—"

But Sneezle interrupted, clutching the crown. "I know who you are."

Now her smile grew colder still as she dropped her mask of friendliness. "I assure you, you don't know me at all. You've no idea what power I have. Give me the crown right now, and *perhaps* I'll let you walk away."

Sneezle backed away from her, squeezing the crown against his chest. He shook his head, terrified by her gaze, unable to speak.

"Do you think you can stand up to me?" She laughed as though she was amused. The sorceress took a graceful step toward the child and cocked her head. "What shall I turn you into, boy? A rat? A mole? A slimy toad? What is it that you fear the most? Fat black spiders? Poisonous snakes? Or maybe . . . yes! You'll make a lovely mosquito, you little pest."

She pointed a thin white hand at him and said a word in the Old Language. Lightning sparked and Sneezle gave a cry. . . .

But nothing happened.

The smile left Rianna's porcelain face. Her eyes flashed angrily. She pointed her hand again, spoke three curt words. . . .

Still nothing happened.

"Someone has put a spell on you. A protection spell! Who was it?" she screeched.

Sneezle turned and ran up the gully, heart thumping and legs churning. He heard the sorceress curse behind him and pushed himself even faster. Rianna leaped into the sky, her shadow looming over the child. He ran, stumbling over roots and rocks, slipping on wet grass, and fell. What was the use in getting up? Winged faeries were always faster than earthbound tree-root faeries like him. He hid his face in the long green grass, shivering with shock and fear, and yet he still held onto the crown for the Faery Queen, and Twig.

Rianna landed beside the little faery and pulled him to his feet. "I'm growing bored with this game, child. I say it's time to end it now. Perhaps my spells won't work on you, but they'll still work on *that*." She pointed a finger at the crown and spoke another word in the Old Language.

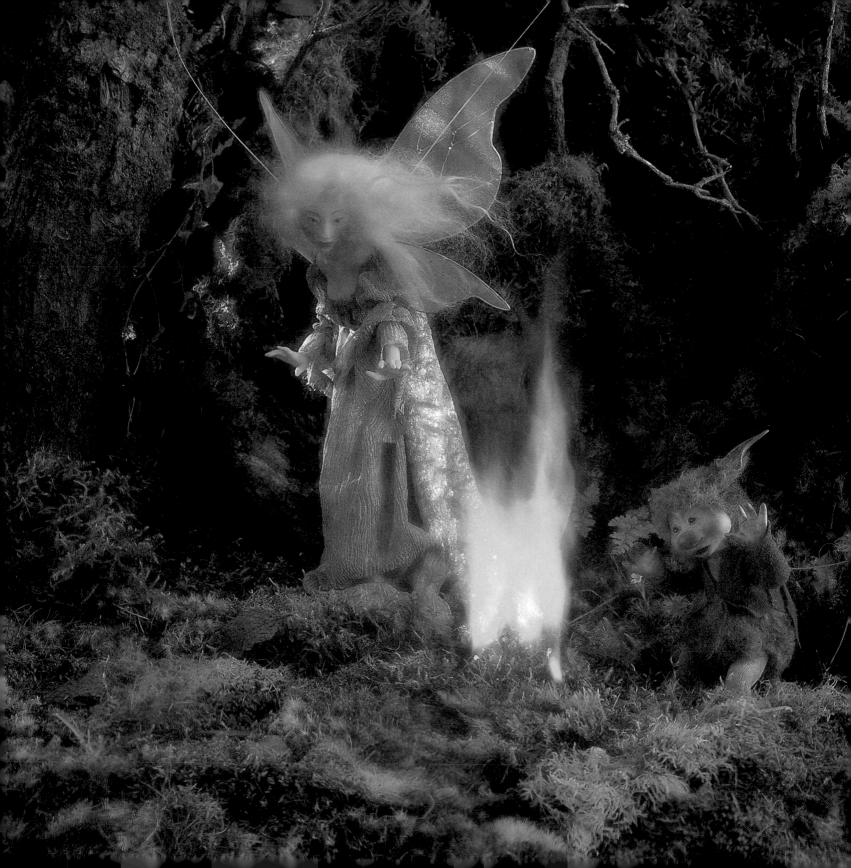

The metal burst into scorching flames and Sneezle howled, dropping it.

The sorceress reached into the circle of flame without fear of its heat, her face triumphant as the fire sputtered and turned into a crown once more. She gave Sneezle her prettiest smile, chilling the little faery's heart. "Thank you for your help, my friend. I'll see you at the Gathering. Never fear, I'll remember *you* when I'm queen of Old Oak Wood."

With a clap of thunder, the sorceress disappeared, leaving smoke and ash behind. Sneezle, trembling, sank down to his knees, shaken and horrified. He'd let Twig down. And his king and queen, and all of the faeries of Old Oak Wood. He sat down in a mushroom ring and earnestly wished that he'd never been born. He'd made a mess of everything. Tears filled his eyes, threatening to spill. He wiped them away—then saw that his traveler's pouch had begun to glow.

He opened the pouch warily. The hazelnut, berry, and stone fell out. Each was warm to the touch, and the smooth white stone was glowing brightly. Magic! They were magical gifts! His ears perked up . . . then drooped again. "I wish I had the crown for Twig instead of some magic stone," he moaned.

The white stone crackled at these words and disappeared in a puff of smoke. In its place was a crown woven out of river reeds and ivy strands, adorned with rowanberries, wildflowers, and small white roses.

The stone had granted his wish! He had a crown to take home to Twig! It wasn't the silver crown, of course . . . but perhaps this was a better one. The other crown had been hard and cold; this was prettier, thought Sneezle—a crown made of rain, wind, woodland earth, and touched by magic.

With the nut and the berry tucked away and the ivy crown slung over his shoulder, Sneezle scurried back to the woodland path and headed homeward. The sun hung low in the western sky, and he quickened his pace across the hills. Passing through groves of alder and beech, through mistletoe, through briar and thorn, Sneezle came at last to familiar lands far from the forest's heart. The sky was streaked with orange and pink as he made his way to the tailors' grove. The place was deserted now, except for Twig, sitting in the shadows.

Her face lit up when Sneezle appeared. She jumped to her feet, ran across the grove, and threw her arms around her friend's neck. "Sneezle, I was worried!"

"Hey, watch out! You'll crush the crown!" Sneezle held it out to Twig and she looked at it dubiously.

"This is Titania's Midsummer crown? I thought it would be a grander thing."

"Oh, but it is grand, don't you see? As beautiful as the wood itself."

But Twig wouldn't take the crown from him. "I can't go to the Gathering. Look at me! I'm still a mess! I went to the godmothers too late. They said that I'm a disgrace." She looked

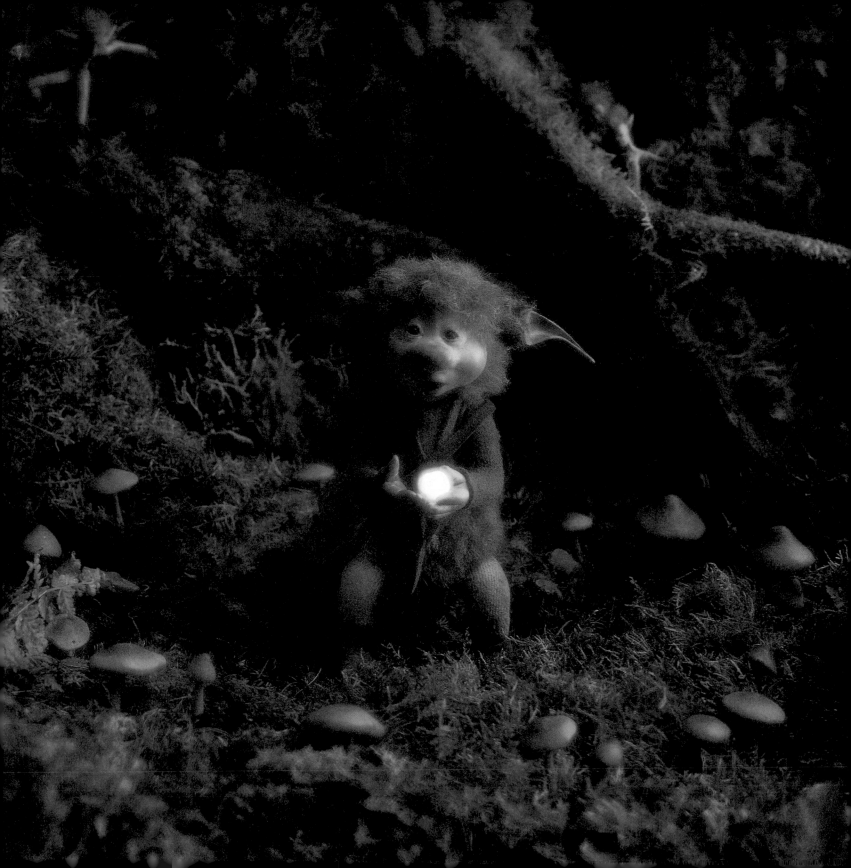

up at him. "You take the crown," she urged. "Give it to Oberon yourself. You won't be an embarrassment, like me—you're so handsome and brave."

"I am?" Sneezle felt his furry face flush.

The other faery turned to go, trailing her tattered, crumpled wings on the ground behind her.

"Don't leave!" Sneezle opened up his pouch and plucked out the red rowanberry. He said, "I wish Twig's wings were clean and straight, just like she wants them."

A clap of thunder split the air, and he dropped the berry in surprise. It disappeared long before it hit the ground, and little Twig gasped.

"Sneezle, Sneezle, look! My wings!" They stretched out from her tiny back, arching smoothly, gracefully, sparkling gold and silver in the light of the dying sun. "They've never looked so beautiful," she breathed, "or felt so good and strong!" To Sneezle's delight, she turned and planted a kiss on his furry cheek.

"Now will you take the crown?" he insisted. "Oberon will be waiting for you."

"Gracious," she said, "it's late, isn't it? We'd better find the king at once."

"He'll be at the Gathering. Come on."

Twig took the crown and Sneezle took Twig's hand, leading the way to the river path. They followed a sparkling trail of piskies, pookas, hobs and nobs and sylphs, all heading south to the Queen's Pavilion and the Midsummer Night's Gathering.

The sun sank low behind the hills. The dusky light turned a silvery blue. The forest stood poised on the edge of enchantment—for twilight is a magical time when the doors between the worlds stand ajar. And twilight on Midsummer Night is the most magical time of all.

Tonight, on the shortest night of the year, the Faery Queen would be crowned anew—just as six months later, on the longest night, the king would be crowned. All of the faeries of the forest were gathering now to celebrate. They came to honor the king and queen, and also Nature itself: the trees, the wind, the stars, and the Lord and Lady of the Wood.

The faeries were dressed in their finest clothes, carrying flowers and masks made of leaves as they filled the Queen's Pavilion beneath silk banners and draperies. Sneezle and Twig pushed their way through the crowd, looking for a sign of the king and his queen. Clutching the hazelnut in his fist, Sneezle watched out for Rianna's bright hair—for if she came here causing trouble, he'd use his last wish up to stop her. The crowd grew hushed as the droning sound of faery bagpipes filled the wood. The king

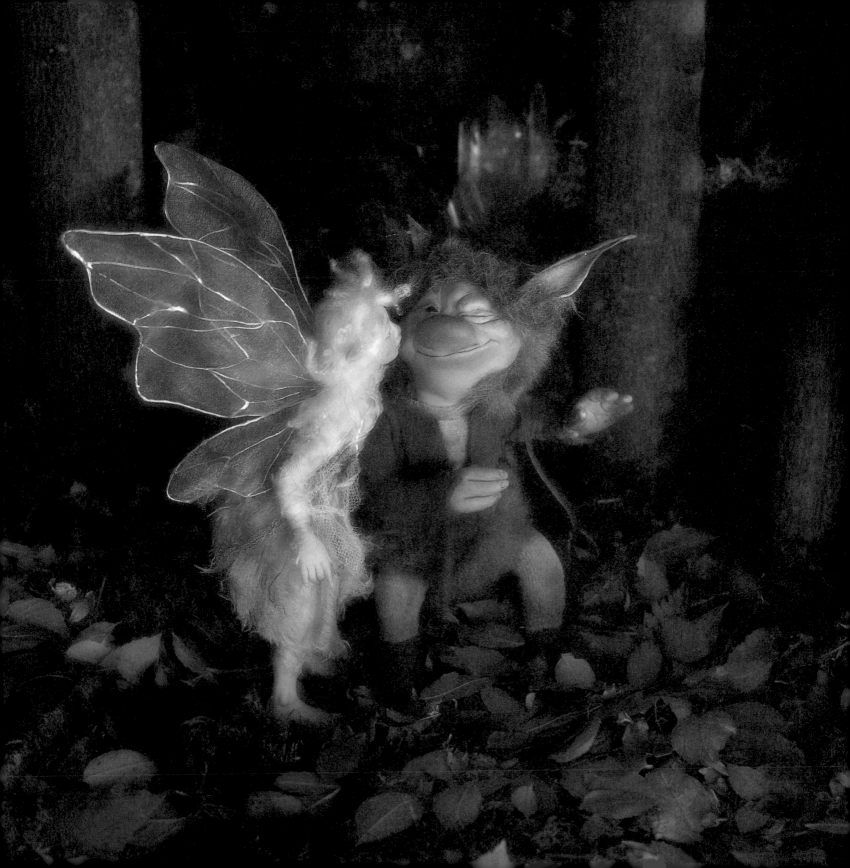

and queen were coming, the sun was down, and the night had started!

The King of Old Oak Wood appeared, magnificent in gray velvet attire, but anguish masked his handsome face as he slowly crossed the grove. He carried Titania in his arms, fast asleep and pale as death. He laid her down on a mossy couch, brushed gold hair back from her brow, stroked her milky cheek, and then rose to face the court.

The crowd fell silent. The music stopped. King Oberon drew breath to speak, his voice trembling with the strength of his emotions as he began. "My friends . . . a wicked magic has come upon us here in Old Oak Wood. It reaches right into the court and strikes my very heart. My queen lies in spell of sleep, trapped somewhere beyond all reach—"

"Your queen?" another voice proclaimed. "Not anymore, Lord Oberon!" Rianna swept into the glade, radiant in the Faery Queen's dress, the very air shimmering around her and the crown held in her hands. "I was summoned to the Heart of the Wood and the oldest oak has spoken to me. The council of oaks wants a new queen this year. They've given *me* the crown."

The gathered faeries gasped as one as Rianna held the crown up high. Voices rose in confusion, surprise, dismay . . . and eager excitement, too, for although the faeries loved Titania, they loved a good drama as well.

"No!" Sneezle cried, but his voice went unheard in the uproar following Rianna's words.

"Sneezle, what's happening?" asked Twig, grabbing her friend by his hands—and causing him to drop the little hazelnut underfoot.

"The wish!" He scrambled on the ground, but the hazelnut had disappeared. Twig pulled Sneezle back up to his feet as Oberon spoke.

"It's a trick. It has to be," the Faery King said in a voice of steel.

"No, it's the will of the oldest oak. *I* am to be your consort now. Aren't you pleased? It seems your old one tires of you, my lord."

"She sleeps because she's under a spell," Oberon countered angrily.

Rianna gave him a dazzling smile. "Never mind Titania now. Am I not twice as beautiful?"

"If you rule this wood, you rule alone," Oberon warned the sorceress.

"Don't be a fool!" the beautiful creature hissed dangerously.

Oberon turned his back on her and knelt down at his lady's side. He took one of Titania's hands in his and gently kissed the palm, his eyes turning from violet to amber to gold with tenderness.

"So be it!" Rianna cried, enraged. "If you won't crown me, I'll crown myself!"

Oberon looked at her with eyes now as blue as those of the true Faery Queen. "It's not up to me to choose the woman worthy to wear the Midsummer crown. The oaks give the crown to the one chosen by the Lord and Lady

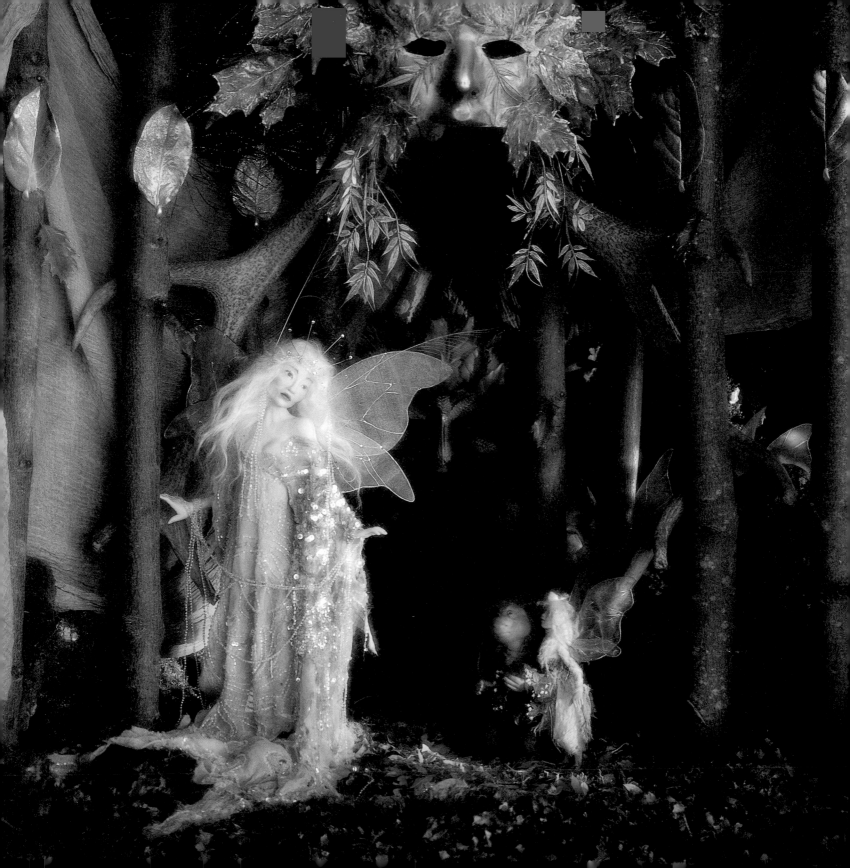

of the Wood."

Rianna's face twisted in a sneer. "Who knows what the Lord and Lady want? Has anyone ever seen them here? I say again that I shall rule, for your lady has lost her crown."

"No she hasn't!" Sneezle yelled, pushing Twig through the jostling crowd. "Give them the ivy crown," he whispered to Twig. "Go on, and hurry!"

Twig stepped forward, trembling, and her soft, shy voice could barely be heard. "Your Majesty, this crown comes from the Heart of Old Oak Wood."

Oberon rose and took the crown from Twig, his eyes now ivy green. "Thank you, child," he said. "This is a beautiful crown indeed."

"What nonsense is this?" Rianna snapped. "That pathetic thing is no Midsummer crown!" And indeed, it looked very humble beside the crown made of silver and jewels.

Yet Oberon held Twig's ivy crown as though it were made of rare elfin gold. "You've mis- understood," he said to Rianna. "You think the Midsummer crown will give you power over Old Oak Wood. But it's not a symbol of power, Rianna—it's a symbol of service to the wood. And now we'll see who the Lord and Lady have chosen to be Faery Queen."

"Yes, we shall!" the sorceress cried. The forest fell into a terrible silence as she placed the silver crown on her head. The air around her crackled with power and the crown glowed with a brilliant light. Rianna smiled tri- umphantly, her gaze sweeping the gathered court . . . and then her expression turned to one of horror, and a deep howl rose from her throat. The crown crumbled into a sooty ash dusting the faery's long white hair. The glitter- ing Midsummer dress turned into cobwebs, shriveled leaves, and moss. The faery's porcelain beauty began to crack into a million shards that clattered like broken crockery to the ground below. The shards turned into fine white dust from which a plain white moth emerged. It circled over the faery court uttering angry little cries, and then sped into the night, leaving stunned silence behind.

Still no one spoke, and in that silence Oberon turned to the Faery Queen, placing the simple ivy crown on his true love's brow. At its touch, Titania stirred. Her eyes fluttered, then opened wide. "My love?" she asked, con- fused. "Where am I?"

"In my arms," said the Faery King. And indeed, in the next moment she was, his lips pressed onto hers.

With that kiss, the ivy crown turned into golden fili- gree adorned with tiny stars that twinkled softly in the twilight. The faeries hollered, whistled, and cheered. "Long live Titania and Oberon! Long live the forest and all things within!"

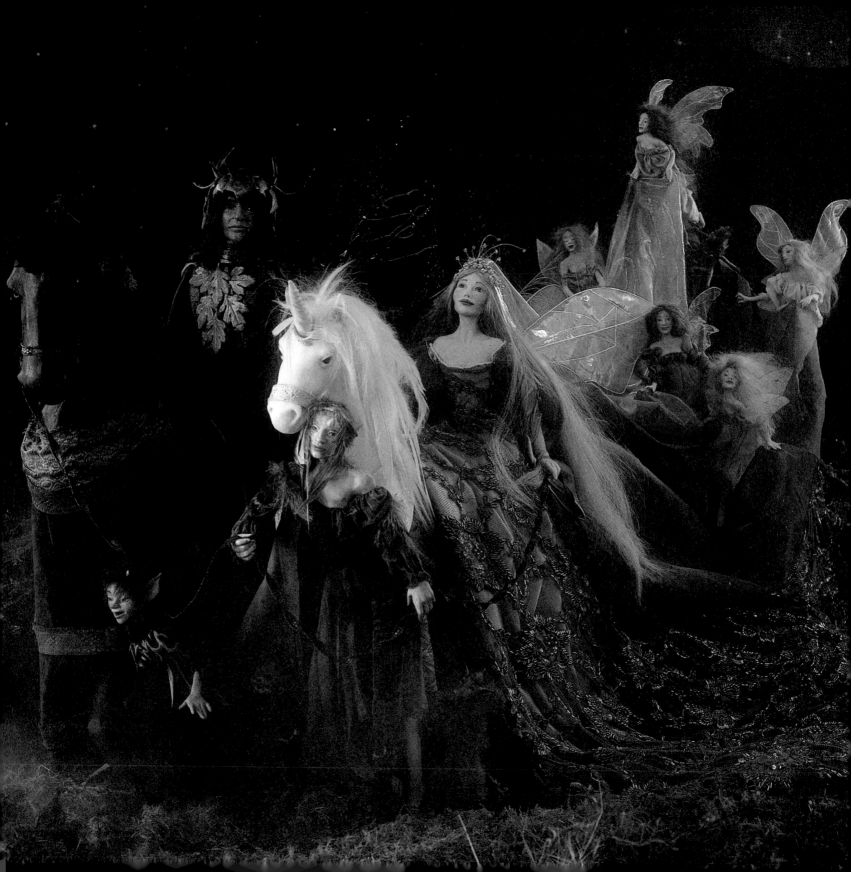

Twig turned, her eyes bright with excitement. "Sneezle, you saved our queen!"

"Shhh!" he said. "It's our secret, remember?"

"I'll always remember," she said solemnly. "You helped me, and the king, and the queen, and all the faery folk of the wood. And even if no one else ever knows about it, *I'll* always know." The sweet smile she gave to Sneezle made the faery's heart flutter, and it seemed an even finer thing than knowing he'd done a good job.

The wood grew dark, and flocks of tiny sylphs appeared in the trees overhead, carrying faery lanterns to light the Midsummer Night's celebration.

Twig tugged at her new friend's arm. "The best part of all is still to come."

"What's that?" he wondered, swallowing a yawn. It had been a long, hard day—but he wasn't going to fall asleep now! This was the part that he'd been waiting for.

"Come on, come on! See for yourself!"

"Wait!" He'd spotted the hazelnut and plucked it from the trampled grass.

"Come on, come on," Twig urged again.

"I'm coming, Twig." He yawned once more. "Will it start right away? I wish I could take a nap, but—"

"Don't be silly!" she exclaimed. "The Gathering has already started and we don't want to miss a minute."

Twig was right. It was Midsummer Night, magic shimmered in the air, and he'd finally made it to the Gathering after all these years! And yet, his steps began to slow. He had to sit, then close his eyes. . . . In the little faery's hand, the magic wish was softly glowing.

In the glade ahead, the king and queen were mounted on their unicorn steeds, the rest of the court stretched out behind them in a bright procession. Each year on Midsummer Night the entire court of Old Oak Wood traveled the boundaries of their land— riding or walking or swimming or flying, each according to his or her nature.

King Oberon and Queen Titania led the way, riding hand in hand. The lantern-bearers flew overhead, the court musicians trailed behind, the stars shone bright, and at the end of the ride the godmothers' feast awaited. All the faeries were gathered now, from the highest court noble to the lowliest root dweller, from boldest to shyest, from big to small. Twig was there, and Uncle Starbucket, and the three handmaidens, and all thirteen godmothers. Everyone, in fact, except poor Sneezle. He was fast asleep.

The moon rose, and set again. The faeries rode from east to west, from north to south, from earth to sky. When morning came, the very last of them staggered home to bed. All that remained of the great procession was a trail of stardust and flower petals, and mist that shimmered on the ground where many faery feet had passed. . . .

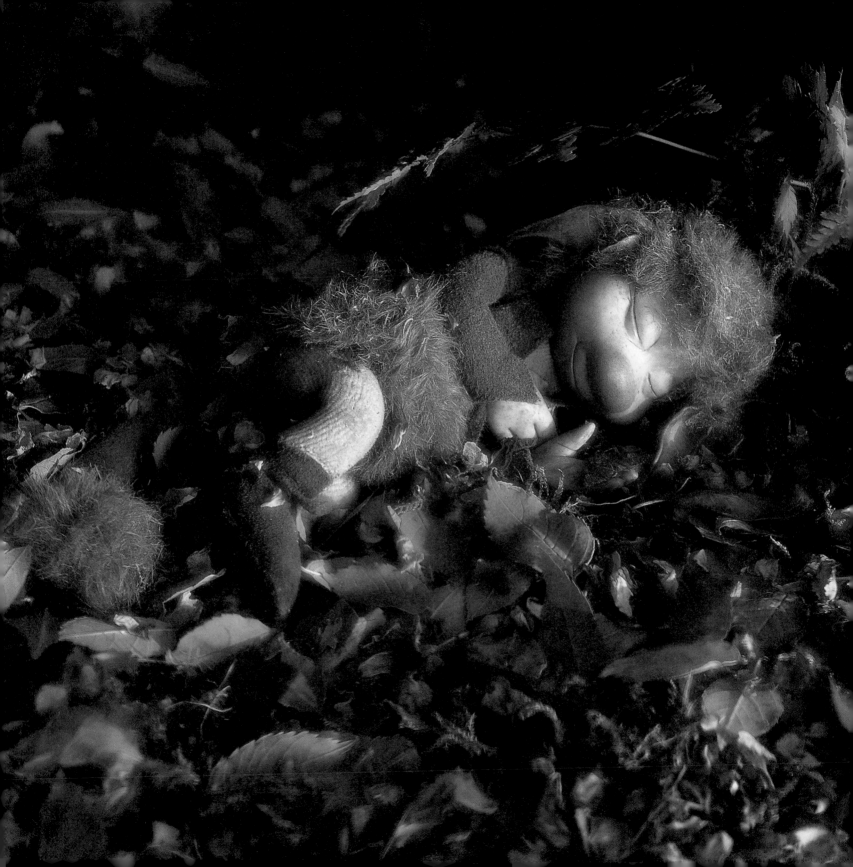

Sneezle stirred, stretched, and woke. Lying on leaves and soft rose petals, he heard the Piper's morning song. The Queen's Pavilion was empty now, but a broad oak leaf was pinned to his pouch. "Sneezle," Twig had written on it in tiny letters of blackberry ink, "I tried and tried to wake you up. I'm sorry! Come find me tomorrow."

Sneezle's ears drooped. He'd done it again! He'd slept and missed Midsummer Night! He'd have to wait a whole long year for another Gathering. "I may be a hero, but I'm still a fool," the downcast little faery groaned. "I still mess everything up. I'm still the same old Sneezle."

"And that's a fine thing to be!" said a voice behind him.

The child turned and saw a radiant man and woman among the trees, dressed in grass-green velvet, crowned with ivy and rowanberries, luminous with the morning light. He knew at once who they must be. "Are you . . . ?"

"The Lord and Lady of the Wood," the lovely woman said. "And you, my little trickster, are Sneezlewort Rootmuster Rowanberry Boggs the Seventh. A proud old name for a fine young faery. We've come to return a wish to you. This one got used up by mistake, I believe. So we've brought it back." She handed Sneezle a hazelnut. "Take it with our blessing, child."

"And use it wisely," her companion added.

"I will," promised Sneezle earnestly. "I'll be much wiser from now on."

"Just be Sneezle. That's good enough," said the raven-haired Lord of the Wood with a smile.

Then the two of them disappeared, turning to dew on ivy and oak. And Sneezle sat, eyes wide with wonder, magic clutched in his small hand . . . as the Piper of the Dawn called the rising sun to a cloudless sky.

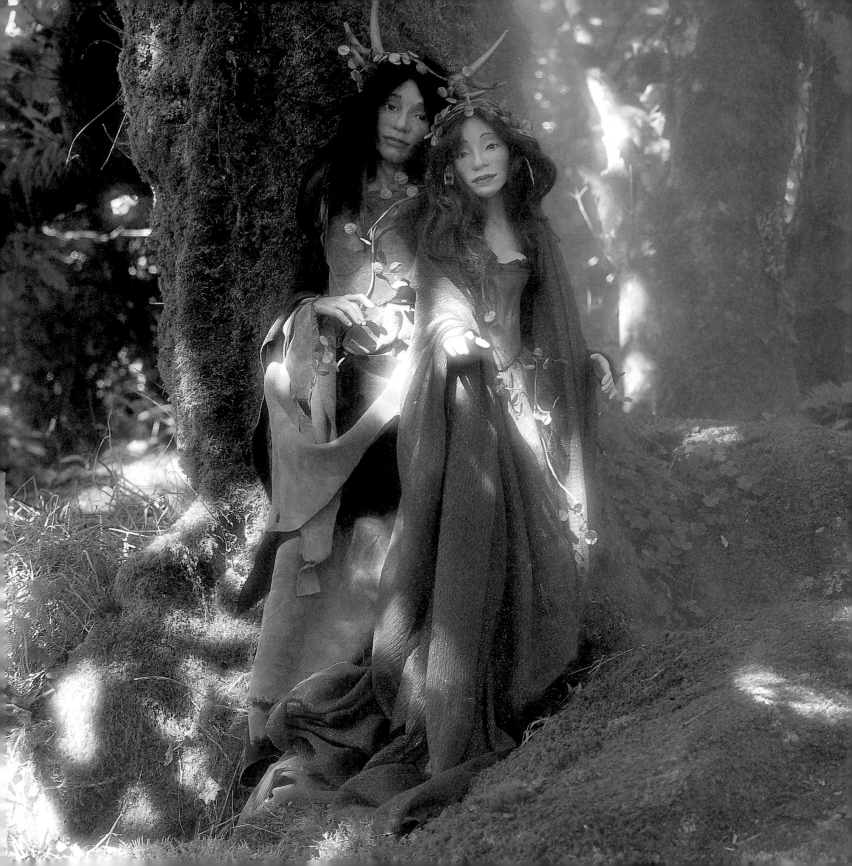

SIMON & SCHUSTER
Rockefeller Center
1230 Avenue of the Americas
New York, NY 10020

SIMON & SCHUSTER and colophon are registered trademarks of
Simon & Schuster, Inc.

Manufactured in the United States of America

10 9 8 7 6 5 4 3 2 1

Library of Congress Cataloging-in-Publication Data
Windling, Terri.
 A midsummer night's faery tale / Wendy Froud & Terri Windling
 p. cm.
 I. Froud, Wendy, date. II. Title
PS3573.I5175M5 1999
813'.54—dc21 99-31525
 CIP

 ISBN 0-684-85559-3

Acknowledgments

Wendy Froud and Terri Windling would like to
thank all the people who helped with this volume:
Brian Froud, Toby Froud, John Lawrence Jones,
Steve Aland, Robert Gould, Ellen Steiber, and
our editor, Constance Herndon.

To my mother,

and to the memory of my father

and Jim Henson.

—W. F.

And to Robert Gould,

fellow traveler

in the faery realm.

—T. W.

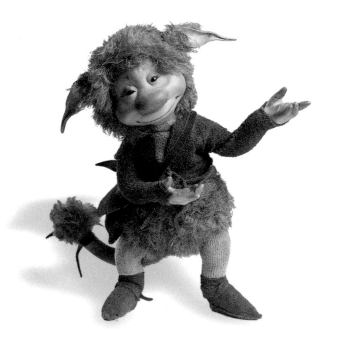

ABOUT THE AUTHORS

A Midsummer Night's Faery Tale is the result of a magical collaboration between the doll and puppet maker Wendy Froud and the award-winning author Terri Windling. The faery world they unveil here so vividly features images of Ms. Froud's handmade figures woven into an enchanting fairy tale for all ages written by Ms. Windling.

WENDY FROUD became a doll maker at the age of five, and has gone on to make dolls, puppets, and sculpture for such films as *The Empire Strikes Back*—she is credited as the fabricator of its beloved character Yoda—and Jim Henson's *The Dark Crystal, Labyrinth, The Muppet Show,* and *The Muppet Movie.* Her dolls and figures are highly sought after by private collectors around the world. Froud grew up in Detroit and now resides in Devon, England, on Dartmoor, with her artist husband, Brian, and their son, Toby.

TERRI WINDLING, a five-time winner of the World Fantasy Award, has been a guiding force in the development of mythic fiction and fantasy literature for more than a decade. Most recently she edited Brian Froud's *Good Faeries/Bad Faeries.* A fairy and folklore scholar, she has written mythic fiction for adults and children (winning the Mythopoeic Award for her novel *The Wood Wife*) and edited more than twenty anthologies. She divides her time between Devon, England, and Tucson, Arizona.

Dear Ms. Valentine,
 Thought I'd share something I love
with you. Thank you for a great year.
Love,
 Courtney Lomax

6/2001